Safety Orange

Forerunners: Ideas First

Short books of thought-in-process scholarship, where intense
analysis, questioning, and speculation take the lead

FROM THE UNIVERSITY OF MINNESOTA PRESS

(Continued on page 76)

Safety Orange

Anna Watkins Fisher

University of Minnesota Press

MINNEAPOLIS

LONDON

Portions of this book were previously published in "Safety Orange,"
Journal of Visual Culture 20, no. 1 (2021): 3–24; copyright 2021 SAGE
Publications; doi: 10.1177/1470412921994603.

View the images discussed in this book at the University of Minnesota Press
Open-Access Library, powered by Manifold: https://manifold.umn.edu.

ISBN 978-1-5179-1339-7 (PB)
ISBN 978-1-4529-6724-0 (Ebook)
ISBN 978-1-4529-6725-7 (Manifold)

Published by the University of Minnesota Press, 2021
111 Third Avenue South, Suite 290
Minneapolis, MN 55401-2520
http://www.upress.umn.edu

Available as a Manifold edition at manifold.umn.edu

The University of Minnesota is an equal-opportunity educator
and employer.

Contents

Introduction: Ordinary Life on High Alert

ORANGE ALARMS. It regulates. It highlights bodies and spaces for oversight. It demands constant vigilance. Orange polarizes. It marks some for protection and others for scrutiny. It is the color of risk management, of infrastructural failure, and of rising global terror, pandemic, and environmental threat. It is a temporary sign of hazard that now hangs permanently. Orange scandalizes. It scams. It misdirects. Nothing rhymes with orange.

This book uses the color orange as an interpretive key for theorizing the uneven distribution of safety and care in the twenty-first-century U.S. social landscape. It examines the institutional history and social politics of one hue in particular: the color "Safety Orange" (also known as "Blaze Orange," "OSHA Orange," and "Hunter Orange"), which has in recent decades become omnipresent in American public life. Today, it is most visible in the contexts of traffic control, work safety, and mass incarceration.

If the U.S. cultural present were a color, it would be Safety Orange. The hue first emerged in the 1950s as a bureaucratic color standard for conveying warning in U.S. technical manuals and federal regulations; it was chosen for its effectiveness in setting objects apart from their natural environment, particularly against blue sky.[1] Around the

1. The hue and value parameters of Safety Orange are set by the American National Standards Institute (ANSI), the organization that

same time, a separate panel of experts determined that fluorescent orange was the most visible color for the most people under the widest variety of conditions. Safety Orange's high visibility has to do with how molecules absorb energy when they are exposed to certain wavelengths of light: UV-reactive fluorescence emits light in the presence of UV radiation, causing a boost in our color perception and making fluorescent colors like Safety Orange appear bolder and brighter to our brains. By the 1960s, the color had been adopted by states across the United States as the mandatory color standard for hunters' safety gear. The color was found to be useful for hunters precisely because it is so unmistakably manmade, "so startlingly vivid and unnatural that it dispels all notion that you are looking at a deer, or anything else occurring in nature."[2]

oversees the development of standards for U.S. products, systems, and services. According to a Google Ngram analysis, the phrase "Safety Orange" first appears in the published transactions of the U.S.-based National Safety Council at their annual National Safety Congresses in the 1950s. By the late 1950s, the term could be found in technical news bulletins, trade and craft journals, and building standards journals. Starting in the early 1960s, Safety Orange was the color most often used in the United States for traffic cones, stanchions, barrels, and other construction-zone marking devices. For more information, see U.S. Department of Transportation, "History of Traffic Cones."

2. In the early 1960s, Massachusetts became the first state to make Hunter Orange mandatory for hunters. The decision followed a study conducted by state, military, and medical experts, who determined that orange was the most visible color under varying lighting and atmospheric conditions for humans if not for other beings (appearing indistinguishable from other colors to deer, for instance). The choice of orange, moreover, accounted for the subset of the population that has color blindness and is thus likely to confuse reds and greens, according to journalist Dave Henderson: "According to the Hunter Education Association, Hunter Orange is the shading 'having a dominant wavelength between 595 and 605 nanometers, a luminance factor of not less than 40 percent and an excitation purity of not less than 85 percent.' In layman's terms, it is a universally recognized, instantly identifiable color that has become the standard in the nation's hunting woods" ("Blaze Orange"). For more on this history, see also Kelleher, "Blaze Orange."

But these days safety is the last thing we associate with Safety Orange, which despite its name now invokes a state of generalized alarm. Today, the color is ubiquitous—a result of developments in advanced liberal or "neoliberal" forms of governance (the shrinking of the state mandate and divestment from national infrastructure and an emphasis on personal choice and self-management), security strategies (defined by the expansion of militarized regimes of control and surveillance at home and abroad), and unsustainable economic growth (the rise of a culture of cheaply produced and highly disposable consumer goods). A relic from the post-9/11 state of exception turned permanent fixture in an era of responsibilization[3] and expanding precarization, orange is the environmental and semiotic expression of these developments in the American public sphere. The color marks the extremes of both state oversight and abandonment, both capitalist excess and dereliction. Safety Orange designates certain bodies for safeguarding (it is used for hazard cones, high-visibility vests, and life jackets) and others as threats (it marks certain prisoners for particular supervision).[4] The U.S. contemporary landscape is saturated in orange, which allows the tracking of bodies, neighborhoods, and infrastructures coded as worthy of care—and of those deemed expendable, and thereby subject to heightened risk of social and ecological death and debility.[5] As such, the color is an exemplary marker of the racial logics behind narratives of "public safety" used to legitimize U.S. militarized policing and securitization.[6] Safety Orange speaks in two registers

3. For a helpful overview of responsibilization as a key feature of neoliberal governance, see Trnka and Trundle, "Competing Responsibilities."

4. OSHA (Occupational Safety and Health Administration) requires certain construction equipment to be painted Safety Orange; Safety Orange (under the name Hunter Orange) is also the color of hats and other safety gear required while hunting in most U.S. states.

5. On debility as a biopolitical concept, see Puar, *Right to Maim.*

6. This follows Ruth Wilson Gilmore's classic definition of racism as "the state-sanctioned or extralegal production and exploitation of group-differentiated vulnerability to premature death" (*Golden Gulag,* 28).

of neoliberal administration: the soft power of state withdrawal, which intones *Please proceed with caution,* and the hard power of the militarized state of exception, which grunts *Keep moving, there is nothing here to see!* The significance of Safety Orange for the current moment lies in the paradoxical effects of its hypervisibility under racial and commodity capitalism: its capacity to *both attract and repel* makes it a useful material index for a phenomenology of neoliberal attention.

Safety Orange is the visual distillation of the excesses of the twenty-first-century U.S. attention economy.[7] The now-famously doomed Fyre Festival was marketed to millennials on Instagram using the empty, contentless signifier of the orange tile. The neon orange block is what social media marketing experts refer to as a "stopper," a visual tactic for disrupting the mindless scrolling habituated by social media.[8] In a crowded marketplace vying for clicks and views, Safety Orange is not simply attention in its purest form but also in its *crudest* form—a cheap marketing shortcut befitting the capitalist aesthetic category of the gimmick, which does almost no real work yet attracts consumer attention.[9] Orange was

7. By twenty-first-century "attention economy," I do not mean only the economization of attention on social media but the broader sense of how governance, resources, and public attention are distributed. Orange offers a lens for inquiry into the capitalist economization and politicization of attention, which feed systems of exploitation and oppression. As writer Tim Griffin anticipated almost two decades ago in a piece on Safety Orange for *Cabinet* magazine, it is the color of the information economy in postindustrial capitalism ("Colors/Safety Orange").

8. The scam Fyre Festival marketing campaign sought to use the neon orange tile to "optimize social media—almost weapon[izing] it." "My whole idea was, like, stop the internet," the festival's former head of marketing Oren Aks explains in the documentary *Fyre Fraud.* "Whatever [other accounts are] posting is not neon orange. That's a stopper . . . and now I've got your attention." Furst and Willoghby, *Fyre Fraud.*

9. According to Sianne Ngai, "the flagrantly unworthy gimmick, our culture's only aesthetic category evoking an abstract idea of price, is also the only one in which our feelings of misgiving stem from a sense of overvaluation bound to appraisals of deficient or excessive labor encoded in form"

the color of the Twitter presidency, the racialization of hypercapitalism, a white supremacist marker of fake tan exceptionalism.[10] (A senior White House official once claimed that Trump's carrot-tinged glow was not the result of countless hours spent self-tanning, but rather, invoking racial eugenics, a sign of good health caused by "good genes."[11]) No shade better captures the garish toxicity of the Trump years, as suggested by protest slogans like "Orange is the New Nixon," "Impeach the Orange!," and "Not My Cheeto."[12] If Twitter is the "fast food" of political communication, orange is authoritarian capitalism's instantaneous delivery system.[13] Orange condenses the perceived abandonment and racist entitlement of Trump's white working-class base (the fluorescent orange "Guns Save Lives" stickers sported by gun rights rallyists and hunter caps worn by rioters who stormed the U.S. Capitol). Brian Massumi's argument about Reagan's turn as an unlikely political idol also applies to Trump: in an image- and information-based age, even an idiotic and incompetent president can be a powerful ideologue

(*Theory of the Gimmick,* 5). See also Ngai's brief discussion of the Fyre Festival as gimmick, 47.

10. For Nick Mirzoeff, it is not orange but blue that is the color of U.S. white supremacy in the age of Trump ("Watching Whiteness Shift to Blue Via Nationalist Aesthetics").

11. Rogers, "In the Pale of Winter." Rather than a postracial attempt to exceed whiteness (as TV studies scholar Hunter Hargraves argues of the racial politics of fake tanning on the show *Jersey Shore*), I understand Trump's orange glow—what the White House has said is the result of "good genes"—as an embodied claim for white nationalism.

12. Digital artist Abhishek Narula captures the orangeness of the Trump presidency with his web-based artwork *Orange Alert,* a parody of the infamous U.S. Homeland Security Advisory System of the 2000s. *Orange Alert* rates the threat level of the current political climate based on Trump's Twitter usage "to tell you whether the Don is spending time thinking about how to govern the country or picking fights on the internet." The rating level is on a scale of one to ten oranges, from a cool "Don is on the Internet" to a raging "Cheetos Dumpster Fire." See https://www.anarula.com/orange-alert.

13. On Trump's use of Twitter to spread his particular style of authoritarian capitalism, see Fuchs, *Digital Demagogue.*

when he telegraphs an affective intensity that can be harnessed to jingoistic ends. Trump's most valuable political commodity is thus his amorphous intensity—the affect invoked by orange.[14] If only partly through its association with Trump, Safety Orange has come to signal both conspicuous consumption and extreme poverty, the color of a nation glutted on misinformation, cheap entertainment, and artificial coloring.

It's not surprising that Safety Orange, remarkable for its usefulness in standing out against the natural environment, is often artificial: chemical-laden and highly processed. But what is less obvious are the toxic ecological and biopolitical effects of its attention-getting material properties. Foods like Cheetos and Fanta get their trademark eye-popping color from Yellow 6 (Sunset Yellow FCF), a petroleum-derived artificial coloring[15] that is one of the three most commonly used synthetic additives in the United States.[16] "Dyes add no benefits whatsoever to foods, other than making them more 'eye-catching' to increase sales"; indeed, these almost uniquely American dyes are actively harmful, linked to cancer, allergic reactions, and hyperactivity in children.[17] Startlingly, the very synthetic dye used

14. Brian Massumi writes of Reagan, "Alone, he was nothing approaching an ideologue. . . . He was unqualified and without content. But the incipience that he was, was prolonged by technologies of image transmission. . . . It was on the receiving end that the Reagan incipience was qualified, given content . . . functionalized and nationalized, [Reagan's projection of confidence] feeds directly into prison construction and neocolonial adventure" ("The Autonomy of Affect," 102–3).

15. Yellow 6 is used to enhance the color of industrial processed foods, such as candy, sports drinks, and breakfast cereals, as well as pet food, clothing, and medication. The International Agency for Research has labeled the food additive Citrus Red 2 a carcinogen, and the FAO/WHO Expert Committee on Food Additives has said that the additive should not be used in foods; it is approved only for coloring the skins of oranges. Kobylewski, "Food Dyes."

16. These also include Red 40 and Yellow 5.

17. Here I cite James Huff, the associate director for chemical carcinogenesis at the National Institute of Environmental Health Sciences' National Toxicology Program. Despite being approved for use in the United

to capture children's attention (Yellow 6) is believed to intensify the symptoms of Attention Deficit Hyperactivity Disorder.[18] In this irony, we already glimpse the curious work of Safety Orange: its contradictory imperative both to *pay attention* and to *not pay attention.*[19]

While the color is in principle designed to motivate actors to take (sometimes costly) protective measures, it also has the opposite effect: its very ubiquity dulls our vigilance against threats and normalizes catastrophic fallout as inevitable. Safety Orange is the "new normal" of the abnormal, the exception—of life lived in unsustainable conditions. It is the lurid warning label for a superlatively bad moment in which U.S. politics is a three-ring circus, the world is on fire, and each passing year qualifies as "the worst year ever." It is the cry for attention of the Age of Perpetual Crisis, the Era of Emergency, "times in which impossible things happen."[20]

There is much to be alarmed about in this near-apocalyptic orange epoch. Humanitarian struggle. Climate catastrophe. Coronavirus pandemic. Species extinction. White supremacist terrorism. Rising authoritarianism. Institutionalized corruption. Corporate monopo-

States by the Food and Drug Administration (which claims they are safe when consumed in small quantities), artificial dyes like Yellow 6 are banned in many other countries, where there is greater government oversight and public scrutiny of consumer product additives. For example, in the U.S. the color of Fanta orange soda comes from Red 40 and Yellow 6; in Britain, it gets its vibrant color from pumpkin and carrot extracts.

18. It bears noting, however, that Attention Deficit Hyperactivity Disorder (ADHD) is not simply inattention but a form of attention dysregulation that is characterized by stimulation-seeking behavior.

19. For an extensive study of the correlation between artificial color additives and ADHD, see Lefferts for the Center for Science in the Public Interest, "Seeing Red."

20. Climate activist Dougald Hine quoted in Beckett, "The Age of Perpetual Crisis." Andy Beckett writes: "How will we remember the last 10 years? Above all, as a time of crises. . . . There were crises at the start of the decade, and there are crises now. Some of them are the same crises, unsolved. Others are like nothing we have experienced before." On the urgency of the contemporary moment, see also Moore, "Introduction: Anthropocene or Capitalocene?"

lization. Extreme poverty. Mental health crisis. These crises (among countless others) are the fodder for a relentless siege of fear and outrage, stoked by social media networks and nonstop news outlets. But this "awareness campaign" often does not invite meaningful action. Instead, we are faced with the depreciated currency of attention: the deadening of our public discourse, the dulling of our cognitive capacities, the narrowing of our emotional bandwidths. Orange's blank intensity is a "stopper" in more ways than one: it conveys constant mass-mediatic stimulation while ensuring mass inaction, warnings sounded but unheeded. In a field of mounting threats, orange at once flashes too much and too little alarm.

In this book, I examine the structural logic that marries the "new abnormal" of Safety Orange—its equivocation, its ambivalence, its contradictory nature, visible in its protection *and* endangerment of bodies, its direction *and* misdirection of attention, its raising *and* normalizing of alarm. Orange tenses, it enervates. But despite its appearance of urgency, Safety Orange is oddly unspecific. It is informational without being informative. The color shows up again and again to signal and mediate the dangers of twenty-first-century capitalism. It exemplifies what Joseph Masco has called the "theater of operations": orange is the abstract vehicle by which "fear and terror have been domesticated as a primary national resource and projected out globally as a twenty-first century American project."[21] It is the chromatic indicator of the U.S. counterterror state's speculative (rather than factual) and generalized (rather than specific) theater of alarm—its expansion "of a world without borders, generating threats without limit."[22]

21. *Theater of Operations*, 3. Joseph Masco argues that this is exemplified in the U.S. Homeland Security Advisory System, which was intended to charge and normalize an atmosphere of alertness. "The alert system addresses citizens not as thinking subjects capable of evaluating information but as raw nerve endings, part of a national nervous system that could be excited to enable a U.S. invasion of Iraq" (24).

22. Masco, 1.

Orange bridges the projects of U.S. state violence at home and abroad; it makes visible the continuity between the global humanitarian crises, so-called wars on terror, and domestic policing and imprisonment campaigns that disproportionately target racialized and (im)migrant communities. The color lifts into view the state's hyperinvestment in security infrastructures and its concomitant broad divestment from the health, media, legal, environmental, and public infrastructures that support the well-being of its citizens. By tracking the color as an object of study—by following how it encodes subjects, objects, affects, and events—the book charts a study of risk, threat, and security in contemporary visual culture; it provides a method for investigating the representational logic of neoliberalism's intensifying impact through ordinary and diffuse phenomena, which often escape our view precisely because they are so commonplace and familiar. Safety Orange binds together phenomena often perceived as unrelated: information networks, climate crisis, securitization, necropolitics, neoliberal policy, Black aesthetic practice, and socially engaged art; a study of orange intersects disciplines and fields including media studies, cultural studies, visual culture, the environmental humanities, security studies, studies of risk, and contemporary art history.

Safety Orange is such a powerful signifier precisely because it is so multiple and diffuse in its signification. The color is curiously dual—it warns of and creates crisis, signifies health and toxicity, stands in for both Black and white, both endangered and dangerous, both local and global; this duality encodes and obscures the uneven distribution of safety and attention in an era of mass privatization, mass consumption, and mass incarceration. Indeed, I argue that Safety Orange is *defined* by its slipperiness—its tendency to flip its referent and to contradict its own meaning. Moreover, it is its constitutive deniability (as when it perpetuates risk while calling it safety) that has made the color such a useful tool for furthering neoliberal market logics. To speak of orange is to make multiple, even seemingly contradictory statements about it as a historical object, a process with effects, and an interpretive key and analytic

framework. The aim of this book is thus to examine the range and registers of Safety Orange's affective and semiotic effects.

On its face, the color standard is a straightforward visual tool by which the state directs public attention to risk by spectacularizing objects and bodies, indexing threat, and interpellating subjects as responsible for their safety. But as I show here, the color purportedly designed to ensure safety has increasingly taken on *antithetical effects*: targeting rather than protecting, dulling rather than focusing attention, normalizing the exception, and replacing action with diffuse alarm. This shift is paradigmatic of the ever-expanding field of advanced liberal governance, for its logics now suffuse the infrastructures of everyday life. The uses of the color foretell the instrumentalization of crisis to install deeper structures of oppression, as T. J. Demos warns in *Beyond the World's End*: he sees "a 'coming barbarism' in our cards, where dominant capitalist political forces . . . instrumentalize the very threat of the end of the world to support their own financial interests."[23] The book examines the color standard's new visibility in the following areas of American neoliberalism: the rise of the security state, the public communication of pandemic and climate risk, the federal divestment from public works, and the expansion of carceral capitalism. Across all of these sites, Safety Orange installs a distinctly neoliberal logic of risk: a warning that is in principle intended to be temporary, specific, and aimed at the public good, but that has in practice been made increasingly *permanent, general,* and *outsourced to individuals.* As the social safety net recedes, orange fills in the gap.

With so many warning signs of social, economic, and biological collapse, how have we found ourselves so woefully unprepared? It is not that Safety Orange does not draw attention to structural issues; certainly, it does. But in a subtle sleight of hand, Safety Orange leverages the aesthetics of state management and emergency pre-

23. Demos, *Beyond the World's End,* 7. Here Demos is paraphrasing Isabelle Stengers's *In Catastrophic Times.*

paredness to condition citizens to a "new normal" of depreciated life under neoliberal, racial, and carbon-based global capitalism. When state and corporate actors use Safety Orange to mark out—draw public attention to—incipient, inconspicuous, or invisible dangers, such as greenhouse gases, COVID-19, or urban blight, they also betray their own divestment from structural change, drawing attention to the gaps and lacks that they refuse to fill. My argument—that Safety Orange serves as a stopgap warning for the systemic failure to address racial and carbon-based capitalism—finds its lay translation in the popular joke about the mechanic who says to the customer: "I couldn't repair your brakes, so I made your horn louder."[24] Through its warning, the traffic cone draws attention to the pothole; but it also performs an act of misdirection. The trappings of safety make citizens responsible for avoiding the now-visible risk, further normalizing a neoliberal order of state nonintervention in public crises, with care instead automated, privatized, and outsourced to citizens. It then lays the blame for the outcomes of systemic harms on the most vulnerable, marking out and scapegoating low-income, racialized individuals and communities marked as "high risk."

This book asks: How are citizens encouraged to accept risk as a sustainable fact of American life (chapter 1)? In the face of a world so obviously imperiled, how does public risk communication normalize crisis as business as usual (chapter 2)? What aesthetic and rhetorical techniques enable the state's withdrawal from social responsibility (chapter 3)? How is orange used as a means of abstracting (and thus disavowing) state racism (chapter 4)? Safety Orange is the catastrophe that is already upon us—the tangerine plumes of burning wildfires brought on by unprecedented heat and winds, the orange alert that forestalls the code red. It spectacularizes crisis and impedes action. It is a sublime fetishization of the status quo. But this is not the end of the story; orange can also have other meanings.

24. This popular quote is commonly attributed to the comedian Steven Wright.

This book not only traces the new forms of neoliberal governance that orange installs and the violence it conceals. But its final chapter also explores: What possibilities and limitations does the color hold for facilitating new forms of solidarity? How has it been taken up by artists who seek to counter the racist politics that subtend the orange state's neoliberal and carceral power (chapter 5)?

Ultimately, Safety Orange is a complicated symbol of the U.S. present. But rather than surrender to the uses to which it is put by neoliberal management, this book ponders how we might imagine and design more just and effective mediatic, rhetorical, and semiotic systems of warning and care for a moment of great urgency.

1. Orange You Glad You Live in America: The United States of Perpetual Risk

IN THE STATE OF MICHIGAN, where I live, locals like to joke that the state flower is the traffic cone. Hearing this for the first time, I chuckled at recognizing a familiar rustbelt landscape of unending—and often, it seems, never-begun—construction. But when I googled the origins of the quip, I learned that the quaint localism is hardly local. As it turns out, the traffic cone is also the state flower in Ohio, Indiana, Montana, Nevada, Pennsylvania, Massachusetts, Texas, and Florida, according to online memes that tell the same joke about different states. The widespread applicability of the joke is telling: in many parts of the U.S., the "temporary" problem of infrastructural disrepair is increasingly perceived as permanent, and what is experienced as uniquely regional is in fact widespread.[1]

Everywhere, hazard warnings overwhelm our sensory fields, on our streets and on our screens. Risk—defined by the *OED* as

1. Long-deferred substantial investment in the country's infrastructure has left "43% of our public roadways . . . in poor or mediocre condition," according to the American Society of Civil Engineers (ASCE). ASCE has called for trillions of dollars of overdue investment to fix U.S. bridges, roads, dams, water systems, power grids, levees, railways, and other infrastructure. See the ASCE's Infrastructure Report Card: https://infrastructurereportcard.org/.

exposure to "the possibility of loss, injury, or other adverse or un-welcome circumstance"—is in principle situational, and therefore temporary. But now, signs warning of risk are a constant presence, and the experience of living under risk has become coextensive with modern life in our "risk society." For Ulrich Beck, who coined the phrase, risk society speaks to a new global awareness of threats that transcend local and national boundaries:

> At the center [of the "logic" of risk production and distribution] lies the risks and consequences of modernization, which are revealed as irreversible threats. . . . Unlike the factory-related or occupational hazards of the nineteenth and the first half of the twentieth centuries, these can no longer be limited to certain localities or groups, but rather exhibit a tendency to globalization which . . . brings into being *supra*-national and *non*-class-specific *global hazards* with a new type of social and political dynamism.[2]

Where Beck argues that risk under global capitalism knows no limits, I hazard that orange operates as a containing mechanism by making risk appear conscribed to a specific context or situation. Orange localizes risk; it counteracts what Beck characterizes as the globalizing dimension inherent to risk society. The traffic cone—the state flower of *every* state—condenses in itself the work of orange: to make systemic failure seem local and situational.

Yet at the same time that the orange traffic cone makes the global appear local—and the endemic seem epidemic—we also see the proliferation of orange in everyday life.[3] The use of traffic cones in

2. Beck, *Risk Society,* 13, emphasis in original. The phrase "of the 'logic' of risk production and distribution" is a direct reference to Beck's previous sentence.

3. In *Cruel Optimism,* Berlant unpacks Foucault's distinction between the epidemic and endemic: "Foucault focuses on biopower's attempt to manage what he calls 'endemics,' which, unlike epidemics, are 'permanent factors . . . [that] sapped the population's strength, shortened the working week,' and 'cost money.' In this shift Foucault dissolves the attention to scenes of *control* over individual life and death under sovereign regimes and refocuses on the dispersed *management* of the . . . threat posed by certain populations to the reproduction of the normatively framed general good life of a society" (97).

U.S. traffic control and public works is heavily regulated by national standards, which specify that the cones are for highly context-specific, short-term use, but traffic cones have traveled beyond the province of road safety; they are increasingly employed to embody a regulatory presence across all facets of life (construction sites, parking lots, competitive sports).[4] Similarly, Safety Orange apparel has spread outside its original context: no longer confined to the woods and construction zones, hunting and workplace safety apparel are now popular street fashion. When these objects meant to convey warning are no longer exceptional but mundane fixtures of everyday life, they curiously become both hypervisible and invisible, screaming "Pay attention" *and* whispering "Ignore me." Social psychologists, engineers, and management scientists working on warning and traffic control signs strive to make signs highly visible—attention-stoppers, like the Fyre Fest orange tile—while at the same time keeping them unobtrusive enough to not distract drivers.[5] One Federal Highway Administration manual highlights this tension between hypervisibility and invisibility: "As the direct means of communication with the traveler, traffic control devices *speak to us softly,* yet effectively and authoritatively."[6] The paradoxes of Safety

4. Safety Orange traffic control materials are approved by the U.S. Department of Transportation Federal Highway Administration to mark objects for "temporary traffic control" and "incident management" (*Manual on Uniform Traffic Control Devices for Streets and Highways,* 10, 30–33).

5. For literature in engineering and management sciences on warning sign design, see Ben-Bassat and Shinar, "Ergonomic Guidelines," 182–95; Wickens, Gordon, and Liu, *Introduction to Human Factors Engineering*; Stridger, "How Readable Are Your Street Signs?" 36–38.

6. Safety Orange paradoxically promises both to alert one to exceptional situations and to normalize those exceptions. This paradoxical design aim is captured, for example, on the U.S. Department of Transportation Federal Highway Administration's website for the *Manual on Uniform Traffic Control Devices for Streets and Highways.* The manual defines its aim as helping citizens "get where [they] want to go safely, efficiently, and comfortably" by creating standards for traffic control devices that "speak to us softly, yet effectively and authoritatively" ("Your MUTCD: Guiding You for over 80 Years").

Orange are deliberate, as the bureaucratic standard was engineered to stand out *and* to blend in, to alert *and* to normalize.

Today, alert warnings are so common that they seem to epitomize the contemporary itself. In 2005 the artist Banksy recreated Claude Monet's "Bridge Over a Pond of Water Lilies," the iconic impressionist masterpiece featuring a Japanese bridge over a water garden. Banksy's version of the late nineteenth-century artwork shows the pond befouled by two half-submerged grocery carts and a single traffic cone. The cone is intended to signal the presence of pollution, which should trigger remediation; instead, here it has itself become a pollutant, forever painted into the landscape.[7] Safety Orange thus captures the paradoxical effects of an ever-expanding field of emergency: as precarization becomes more and more endemic, more broadly distributed, the crisis it poses is increasingly naturalized, made ordinary, and rendered part of the scenery of daily life.

The world itself is turning orange. We are inundated with images of a globe stitched together in varying and intensifying shades of orange, representing varying and intensifying levels of danger. Orange is a stretching threshold of uncertainty, threatening to turn full-blown red. Orange is the sensorium of existential global risk as it is produced through real-time data science visualizations: coronavirus contagion maps, climate warnings with heat indexes showing rising temperatures, terrorist warning levels—all charting a world in which crisis is not simply imminent but, paradoxically, *chronically imminent.*

Orange's sensorium of chronic imminence is delivered through an elaborate semiotic and mediatic apparatus. "Because risk is virtual," Bhaskar Sarkar and Bishnupriya Ghosh explain, we "require

7. Another well-known experiment with the traffic cone is artist Dennis Oppenheim's *Safety Cones*, eighteen-foot-high public sculptures made of fiberglass, steel, and acrylic. Or to take a more quotidian example, we can think of the tradition of pranksters placing traffic cones on the heads of historic statues in city centers, a gesture that refuses the sanctification of historical monuments. See, for example, *BBC News,* "Why Do People Put Traffic Cones on Statues?"

mediation to render [it] legible. Risk perceptions depend on mediatized forms, from tables, bar diagrams, and graphs (generated via regression analyses) to color-coded emergency alerts (chromatic transcriptions of threat levels) to geospatial models (generated by live-tracking of winds, currents, moving landmass, etc.)."[8] Often, however, these mediatized forms do not enable knowledge about crises and empower us to resolve them; instead, as Wendy Hui Kyong Chun has argued, these forms "undermine the agency they promise," multiplying crises and intensifying the complex processes they supposedly document. "From financial crises linked to complex software programs to diagnoses and predictions of global climate change that depend on the use of super computers, from the undetected computer viruses to bombings at securitized airports," Chun observes, "we are increasingly called on both to trust coded systems and to prepare for events that elude them."[9]

What Chun points to is the oddly unhelpful nature of Safety Orange's call to be prepared. These warnings often convey uncertainty rather than knowledge, paralyze rather than mobilize. Building on Mary Ann Doane's account of how television organizes time, Chun argues that never-ending crisis structures the temporality of new media.[10] While TV relishes the spectacle of *catastrophe*,

8. Ghosh and Sarkar, "Media and Risk," 4.
9. Chun, *Updating to Remain the Same,* 70.
10. Doane distinguishes three modes by which TV apprehends the event: information, crisis, and catastrophe. Information names "the steady stream of daily 'newsworthy' events characterized by their regularity"; crisis quickens the flow of everyday news without fully disrupting it; and catastrophe is "the most critical of crises for its timing is that of the instantaneous, the moment, the punctual." Hence, TV relishes catastrophe, for it is the moment when the viewer, transfixed to the screen, is most immediately "in touch" with the real. While information and catastrophe are thought to be subjectless, crisis demands resolution, requiring that a subject take charge (making it eminently political) ("Information, Crisis, Catastrophe," 252). While TV today is often indissociable from new media, the catastrophic televisual form of live TV that Doane discusses is the temporality of the 24/7 news cycle, not the "on demand" temporality of

new media feed on *crisis*: they compel users to be constantly ready to act while weakening the meaning of action. Unlike the passive TV watcher, figured as a couch potato, new media promises its users agency through participation. Instead, new media deliver the nonreality of endless virtual exchange: "The decisions we make . . . seem to prolong crises rather than end them, trapping us in a never-advancing present."[11] This hyperactivity without agency reflects the American cultural mood under the Orange Presidency. Recalling Siegfried Kracauer's 1927 diagnosis of life in Weimar Germany, Hal Foster has written of media effects under Trump: "Never before has an age been so *informed* about itself [and] never before has a period *known* so little about itself." Foster observes: "This paradoxical condition—whereby superabundant information undermines actual knowledge—is heightened by our media environment, which overwhelms us with data even as it deskills us in interpretation, which connects us even as it untethers us."[12] To put it another way, orange's very semiotic instability reminds us that clear communication requires a stable semiotic field.[13]

Bolstering this widespread sense of crisis paralysis, we might say that the Trump media economy *cried Safety Orange,* exploiting fear and outrage for profit and attention, trafficking in hyperbole and misinformation, and in the process undermining the footholds for

streaming digital TV services like Netflix. On a social media platform like Twitter, televisual catastrophe continues to play out live before a transfixed spectator, but the constant flow of catastrophe, perpetual catastrophe, has converted it into chronic crisis, demoting it to background noise (until the next catastrophe shocks and recalibrates our short attention spans). On the chronic and heightened forms of attention demanded by new media, see also Crary, *24/7,* and Pettman, *Infinite Distraction.*

11. Chun, *Updating to Remain the Same,* 76.

12. Foster, "Père Trump," 3, emphasis in original.

13. Selected as a color standard for its ability to pop against blue sky, Safety Orange thus requires a "normal," nontoxic environment for its warning to be perceptible: it cannot register when the entire sky is orange, as it was in the Bay Area in September 2020 when the usual fog converged with the smoke from burning wildfires, exacerbated by climate change.

meaningful political communication. (Trump's frequent recourse to the adjective "special," for example, as one journalist put it, "is almost a mark of how deadened his rhetoric is.")[14] Trump's erosion of the power of language, necessary to communicate appropriate warning, is especially ironic given the heightened dangers of the moment. This irony was tragically illustrated by one Stanford climate scientist's description of the orange sky caused by spreading wildfires that appeared above San Francisco in late 2020 as an "exclamation point" on the intensifying reality of climate change.[15] For Foster, "the problem is, the old concepts seem inadequate in the face of Trumpism, voided not only by the sheer scale of the calamity but also by its weird mix of the buffoonish and the lethal."[16] In her own discussion of Trump's compulsion to exaggeration (specifically his use of exclamation points in his tweets), Sara Ahmed observes that overuse to the point of uselessness, counterintuitively, can serve a purpose: "When someone is judged as overusing a sign," Ahmed writes, "we mean it has ceased to be effective for a specific purpose. But that cessation can be the point of how something is used; the point can be to stop something from working as it usually works, to repurpose a tool."[17] Following Ahmed, we might ask, What is the purpose of Safety Orange's overuse? Why does it urgently demand our attention but not point to any clear action? The overuse of orange, I propose, works to untether the sign of caution from its object. It renders the warning intransitive, and thus inoperative as a warning. The ubiquity of the color serves to undermine its traditional use to sound alarm, and thus its usefulness for distinguishing between what requires immediate attention and what does not.

Orange has been repurposed: its work is no longer to prepare citizens for a specific imminent, identifiable, and actionable danger but to condition them to be ready for anything. Safety Orange is thus

14. Sorkin, "Trump Wanted a Big Sendoff—and Didn't Get It."
15. Rexroat, "The Day the San Francisco Sky Turned Orange."
16. Foster, "Père Trump," 3.
17. Ahmed, *What's the Use?*, 53.

exemplary of the ideological paradigm of *preparedness*. Lindsay
Thomas argues that this U.S. national security paradigm—traceable
to Cold War imperatives of nuclear readiness, operationalized in
civil defense exercises—normalizes disaster by confusing fiction
with reality by asking subjects to regard hypothetical disaster events
"as if they are real."[18] As a logic of governance, preparedness is con-
cerned not with the prevention of disasters but with habituating
citizens to anticipate them before they happen—to accept their
inevitability. "Preparedness training focuses on teaching people
to regard disaster as normal. This normalization positions events
like natural disasters, industrial accidents, and disease outbreaks as
equivalent to terrorist attacks: all are threats to national security, all
are inevitable or unstoppable, and all should be expected as part of
daily life."[19] For Thomas, preparedness is a form of "affective train-
ing" that habituates citizens to a "new normal" of chronic disaster.
It trains us to relinquish demands for systemic transformation by
accepting a future based on present conditions: "Preparedness me-
dia cultivates this feeling of always-alert detachment because it is
politically expedient. It emphasizes the maintenance of the status
quo—the extension of the present into the future, indefinitely—over
meaningful change."[20]

Safety Orange's repurposing into a technology of preparedness
has two key effects. First, by overusing the aesthetic and rhetoric
of emergency, the state deflects examination of the slow violence
of systemic crises (climate change, racial injustice, public infra-
structural breakdown). Emergency demands immediate action, but
immediacy is not what is needed in the face of "disasters that are on-
going, slow moving, and nonlocal"—all problems that are intractable
at the individual level.[21] Second, by prompting citizens to imagine

18. Thomas, *Training for Catastrophe*, 5.
19. Thomas, 5.
20. Thomas, "Forms of Duration," 160, 162.
21. Thomas writes: "Preparedness media's emphasis on instantaneous
response is ineffective or even meaningless when tasked with the manage-

themselves as survivors of imminent catastrophes, Safety Orange compels adaptation to a constantly precarious state of affairs.

Perhaps the most iconic illustration of the peculiar temporal logic of perpetual risk, at least within the U.S. cultural idiom, is the widely mocked color-coded Homeland Security Advisory System introduced by a Bush administration presidential directive in the aftermath of 9/11. During the decade that followed, it was common to hear the national threat level announced in U.S. airports—usually Code Orange, designating "high risk" of terrorist attack.[22] When then-Homeland Security secretary Tom Ridge raised the national alert level to orange in December 2003, the threat warning was followed by a statement to citizens to "continue with your holiday plans." As Joseph Masco argues of the true purpose of the orange alert: "This is an official appeal to participate in being generally terrorized, followed by an appeal not to alter one's life in any significant manner. It is an invitation to pure excitement."[23] Over the nine-year life of the system, the threat level was never reduced to "low" (green) or "guarded" (blue), and only once was it ever raised to "severe" (red).[24] In the years since 9/11, there has been no return to normalcy (green) and, perhaps even more surprisingly, no collapse into full-blown catastrophe (red). What we live in, instead, is an era of intensified risk made interminable.

Safety Orange says, *Pay attention! Be vigilant!* Orange is the chromatic expression of contemporary crisis' paralyzing call to action. It is the urgently vague *something* in the post-9/11 National Terrorism

ment of climate change. How do we respond immediately to disasters that are ongoing, slow moving, and nonlocal? What does 'real-time response' entail in this context?" ("Forms of Duration," 162).

22. For a discussion of the U.S. Homeland Security Advisory System and Code Orange, see Masco, *Theater of Operations*, 21–26.

23. Masco, 22.

24. The U.S. Department of Homeland Security retired the system in 2011, replaced by web-based "bulletins" that have been criticized for being inconsistently updated and largely ignored by the American public. (Brill, "Is America Any Safer?").

Advisory System mantra "If you see something, say something."[25] But what do we do with what we notice? The color demands response but gives no clear directive. Failure to learn the lessons of the terror alert system, which failed because it offered no actionable steps for citizens to follow, has played out in public communications about COVID-19 and climate change.[26] What good are crisis alerts when they offer no guidelines for what to do? Without protective equipment and testing available, what is the point of contact tracing?[27] Without a halt on global corporate emissions, what good is an individual citizen's decision to drive less? Indeed, many of these urgent warnings of crisis cannot be meaningfully responded to by individual citizens, although the warnings themselves put the responsibility on individual shoulders. If the warnings of COVID-19 transmission or global temperatures rising are not meant to prompt specific action, what are they meant for?

What the coronavirus and climate crises have laid bare, in the United States in particular but also other parts of the world, is that neoliberal governments do not convey clear and accurate information but leave citizens on their own to make calculations about their health and safety and to weigh the consequences of their actions

25. For a discussion of problems with the color-coded U.S. Homeland Security Advisory System, see Shapiro and Cohen, "Color Bind."

26. Masco observes of raising the threat alert level on the U.S. Homeland Security Advisory System: "Although the threat level had immediate implications for transportation security, police, and first responders, announcements of shifts in the system were rarely accompanied by discussions of actual sources of information, as officials sought to protect their sources and methods of intelligence during wartime" (*Theater of Operations*, 22).

27. Boris Johnson's U.K. government received widespread criticism for its May 2020 decision to change the coronavirus safety campaign slogan from "Stay at Home, Protect the NHS, Save Lives" to "Stay Alert, Control the Virus, Save Lives." Critics argued that the warning evaded responsibility by not issuing clear public directives for how to avoid catching and spreading the virus. See Pearce, "Feeling Alert?"; Eardley, "Coronavirus"; and Hickman, "PR Pros."

as though they were matters of personal choice—and thereby to shoulder the extreme human and environmental toll wrought by this dynamic. What we need is not new or better metrics of risk assessment but structural change by those empowered to make it. However, as I explore in the next chapter, orange can be used to prevent us from imagining meaningful transformations, just as Thomas's "affective training" by preparedness trains us to accept a future based on present conditions. By associating catastrophic risk, coded in orange, with securitization, public pandemic and climate change risk communications do not motivate critical radical action but instead instill a dangerous sense of complacency.

2. Orange beyond Orange: Normalizing Catastrophe in Public Risk Communication

IF SAFETY ORANGE IS THE EMBLEM of this chronic state of high alert, we might say that the hands of the Doomsday Clock point to orange. Operated by the Bulletin of Atomic Scientists, the Doomsday Clock measures the world's vulnerability to global catastrophe (nuclear weapons, climate change, cyberwar). The hands had held at two minutes to midnight—two minutes to global catastrophe—since January 2018; in 2020, the hands ticked forward to one hundred seconds to midnight.[1] The clock ticking forward seems inexorable, a product of what the Bulletin's Science and Security Board called in 2019 the "new abnormal": the unsustainable new world order, maintained by the inaction of global leaders and enabled by

1. The Doomsday Clock announcement includes the following boilerplate "editor's note" about its creation: "Founded in 1945 by University of Chicago scientists who had helped develop the first atomic weapons in the Manhattan Project, the Bulletin of the Atomic Scientists created the Doomsday Clock two years later, using the imagery of apocalypse (midnight) and the contemporary idiom of nuclear explosion (countdown to zero) to convey threats to humanity and the planet. The decision to move (or to leave in place) the minute hand of the Doomsday Clock is made every year by the Bulletin's Science and Security Board (SASB) in consultation with its Board of Sponsors, which includes 13 Nobel laureates." Science and Security Board, "2019 Doomsday Clock Statement."

the widespread disinformation that is "lulling citizens around the world into a dangerous sense of anomie and political paralysis."[2] The Doomsday Clock is a public-facing project intended to convey in the clearest possible terms the probability of irreversible planetary disaster in order to provoke radical action. However, as I showed in the previous chapter, the effect of living under the perpetual ticking down to catastrophe—of always living at Threat Level Orange—is one of frustrating action, not encouraging it. The constant awareness of doom produces crisis paralysis, desensitizing by hyperstimulating.

In principle, a clock counts down the passage of time. But the Doomsday Clock works probabilistically, and it is therefore asymptotic: it does not tell time or indicate when the end of the world will come but instead infinitely defers something presented as inevitable. By speaking in a speculative tense, it continually allows for some margin of risk—and thus some margin of hope and doubt.[3] The probabilistic logic of the clock dictates that one can never escape the apocalypse—but by the same logic, paradoxically, one can also never reach it. The Doomsday Clock, like Safety Orange, does not simply highlight the fact that the planet is headed for climate disaster; it highlights the gap between where we are and the impending catastrophe (temporalized as one hundred seconds). The clock, whose predictions are based in statistical knowledge, unintentionally opens an interval of uncertainty—an interval that can be seized as an alibi for maintaining the status quo.

2. Science and Security Board.

3. In *The Great Derangement,* Ghosh argues that probability and improbability are not opposites (unlike the possible and the impossible): "*Improbable* is not the opposite of probable, but rather an inflection on it, a gradient in a continuum of probability" (16, emphasis in original). This means that a probabilistic logic forecloses the possibility of an extreme event, which defies the laws governing what is considered realistic. Ghosh argues that if climate disaster is so far outside fiction's imaginative scope that it cannot be integrated into a novel, it is because novels have integrated probabilities as their internal logic—they have adopted the probable as their horizon.

According to climate organizer George Marshall, even the meaning of the word "uncertainty" can be exploited to stifle action. In his book on the psychology of climate denial, *Don't Even Think About It,* Marshall explains,

> There is even widespread uncertainty over the very meaning of the word *uncertainty.* The precise language of science uses the word to mean the extent to which the weight of available evidence supports a conclusion. Scientists argue that full certainty is unattainable, indeed damaging, and that the maintenance of doubt is the very *foundation* of the scientific method. However, the lay public uses the word in a quite different way: to mean the extent to which the expert is confident in his or her stated opinion. When scientists say *uncertain,* the public hears *unsure,* and considers them less reliable or trustworthy.[4]

This interval of uncertainty is opened up by the scientific and liberal recognition of the contingency inherent in knowledge practices, but this nuance is exploited by those whose financial interests would be affected by climate change action—conservative political elites, as well as coal, rail, and utility companies.[5] These actors exploit the interval of uncertainty, turning precision against them by highlighting its contingency or uncertainty—representing it as "just a theory."[6]

4. Marshall, *Don't Even Think About It,* 73, emphasis in original.

5. A 2019 report by the Climate and Development Lab (CDL) at Brown University showed that fossil fuel trade groups spent $1 billion between 2008 and 2017 on PR and advertising, over 15 times the amount spent by renewable energy trade groups ("American Utilities and the Climate Change Countermovement").

6. The suggestion by pro-Trump climate deniers that climate change is "uncertain" is what Naomi Klein challenges when she asserts that climate change *"changes everything,"* in other words, that it is predictable and real. In a passing remark, Barbara Herrnstein Smith chides Naomi Klein for her hyperbolic use of "everything" in the title of her 2014 book *This Changes Everything* (109, emphasis in original). However, I read the certainty Klein summons in her title as a consciously performative (rather than naïve) insistence, and moreover not an assertion of scientific certainty but of political certainty. As such, Klein's use of hyperbole is very different from Trump's authoritarian use of hyperbole. When Trump uses hyperbole he capitalizes on the idea that he has the power and authority to claim certainty when science cannot.

The "post-truth" media environment aside, as Marshall's book argues, motivating the public to act on climate change already brings with it significant psychological and public relations challenges.[7] As climate communication expert Sean Munger warns: "Climate change lacks salience, meaning that it does not rise to the level of threat necessary to trigger humans' fight-or-flight responses; dealing with it requires immediate trade-offs of people's standards of living to ameliorate potential future harms that are perceived as distant and speculative; and climate change seems, to many people, to be contested and uncertain."[8] Much recent work on climate change has sought to shorten the timescale and make concrete the risks: David Wallace-Wells's bracing 2019 book *The Uninhabitable Earth* seeks to shatter public complacency by looking beyond "business-as-usual" warming projections to examine the "brutal long tail" of worst-case-scenario climate predictions. The book's opening line: "It is worse, much worse, than you think."[9] And the warnings are growing more, not less, dire: in a peer-reviewed article published in early 2021, seventeen scientists describe the coming climate future if we continue at our current pace as "ghastly": "Humanity is causing a rapid loss of biodiversity and, with it, Earth's ability to support complex life," they write; nevertheless, "the mainstream is having difficulty grasping the magnitude of this loss, despite the steady erosion of the fabric of human civilization."[10]

7. Climate communication experts often note that most people perceive climate change as a far-off threat. Engaging the public on the issue means surmounting the public's psychological distance from the issue. "We humans have well documented difficulties with grasping long-term, gradually changing issues that are complex and system wide," explains Climate Outreach, a U.K.-based organization that works to build social acceptance of climate change ("Managing the Psychological Distance," 1).

8. Munger, "Avoiding Dispatches from Hell," 118.

9. Wallace-Wells, *The Uninhabitable Earth*, 3.

10. Bradshaw et al, "Underestimating the Challenges," 1. "Widespread ignorance of human behavior and the incremental nature of socio-political processes that plan and implement solutions further delay effective action," the report reads (2). For an excellent analysis of the article's reception and consequence, see Ehrenreich, "We're Hurtling toward Global Suicide."

Safety Orange plays on a confusion between *present* and *future* as well as between what is *probable* and what is *imminent*. This temporal confusion is particularly dangerous when it comes to climate change, which is in fact both urgent and (to a large degree) mitigable; when scientific uncertainty is treated as doubt, and when present comfort trumps future safety, however, we can ignore the likely lasting effects of climate change, which (depending on our behavior now) could be either manageable or apocalyptic. Munger explains:

> Even fully achieving the optimistic goal of the Paris Accords of hold-ing warming to 1.5°C by 2100 comes with considerable setbacks, for example, "committed sea level rise" that is projected to occur re-gardless of whatever CO2 mitigation actions are taken now. While this is undeniably a reality of the climate change situation, it creates a difficult selling dilemma: let's sacrifice today to live in a world that's significantly worse than the one we have now, but one that is *less* bad than the one we'll have if we do *not* sacrifice. . . . When viewed this way, it is unsurprising that messaging attempts that try to motivate behavior change by "turning up the dial" on depicting apocalyptic futures make no real difference to audiences, and some-times even backfire.[11]

Too-dire risk communications can foster inaction in the present—why bother?—but equally, not-dire-enough risk communications can foster complacency, reducing the sense of threat posed by climate change. This catch-22 is a sort of messaging standoff—a standoff emblematized by the color orange in environmental risk visualizations.

Take the color spectrum—green to yellow to red—used in pub-lic risk communications to convey rising heat indexes in climate change models or increasing spread in maps tracking coronavirus infections.[12] Such data visualizations implicitly rely on what design-ers call "learned colors," for they are based on the familiar hazard

11. Munger, Avoiding Dispatches from Hell, 122, emphases in original.
12. Rost, "What to Consider." See also Lin and Heer, "Right Colors."

range of green-amber-red (like a traffic light they indicate *green=go*, *red=stop*).[13] In this scenario, orange falls into an age-old problem: the representation of averages as desirable. As Jill Walker Rettberg explains: "The power of visualizations to show averages and patterns contributed to the nineteenth-century privileging of the 'norm,' or . . . a 'generalized notion of the normal as an imperative,' where 'the average then paradoxically becomes a kind of ideal, a position to be wished.'"[14] The visual risk index color scale implicitly presents orange, which is the median color of the scale, as the norm; within the chromatic logic of these visualizations, orange appears as a safe middle ground between green and red. But just as the Doomsday Clock *cannot* reach midnight (or it would annihilate itself), there can never be green or red but *only orange*—represented in varying shades of intensity—when color is used to visualize the probability of risk. In an unquantifiable apocalyptic future, so long as risk exists, we can only eternally hover at orange.[15]

Thus, when used to represent data values, orange cannot be a vector of meaningful change. Instead, it operates as a regulating

13. Journalist Maryn McKenna notes the ableism and cultural and literacy assumptions bound up in these color-coded visualizations: "Ordering risky activities top to bottom like a list, or left to right like a scientific chart, might seem a simple choice, as self-evident a communication strategy as borrowing the green-yellow-red symbolism of a traffic light. In fact, though, it involves assumptions: about an audience's cultural background, about their graphic and data literacy, even about their ability to see color. (About 8 percent of men with European Caucasian ancestry and at least 4 percent of men of Asian heritage have red-green color blindness; the rates are much lower in women.)" ("Navigate Risk").

14. Walker Rettberg, "Ways of Knowing," 40.

15. In design terms, both color and brightness contrasts can be used to convey warning. Marc Green, an expert in the psychology of vision and information processing when applied to warning signs, explains: "One important distinction between sets of colors is whether they create brightness (achromatic) or color (chromatic) contrast. Both kinds of contrast make objects stand out from their backgrounds. However, there are significant differences in the properties of color and brightness contrast" ("Color Discrimination").

mechanism that simply upholds the status quo, suspended between a (green) past and an ever-deferred (red) future. Rather than mitigating crises, orange represents them as stable and manageable— as *sustainable*. But, as Michelle C. Neely argues, sustainability is a "capitalist-compatible paradigm" that privileges the capitalist growth imperative over the ethics of environmental justice. "As the planet edges toward disaster," Neely writes, "sustainability's tendency to look for a middle ground that protects the portfolio interests of the few over the present and future well-being of the many comes to seem more and more absurd."[16] Because the paradigm "fundamentally prizes not transformation but continuity," as she argues, "sustainability's reassuring emphasis on stability comes at a high cost."[17] Orange is precisely that "middle ground" between red and green, between stop and go. It is the color of incrementalism, of compromise, of maintaining business as usual.

It is appropriate that these risk visualizations rely on the "semantic resonance" of the traffic light color palette, for the first three-color traffic light was invented in 1920 in Detroit (the automobile manufacturing capital of the world) to respond to the risks associated with U.S. industrialization: in the early days of automobiles, there was little to govern traffic flow except for police officers who stood in the road directing traffic, and accidents were common and dangerous.[18] To reduce the risk, cities began installing two-colored traffic lights (*red/stop* and *green/go*) at crossroads, telling drivers when to stop for crossing traffic.[19] Over time, as road traffic contin-

16. Neely, *Against Sustainability*, 8.

17. Neely, 9.

18. The addition of the yellow light to the stoplight was the brainchild of Detroit police officer William Potts, who had studied electrical engineering. Though as a municipal employee he was unable to patent it, he invented the three-color stoplight by building on the two-color stoplight design of Cleveland engineer James Hoge. Nelson, "Brief History."

19. "Many concepts evoke related colors—whether due to physical appearance, common metaphors, or cultural conventions. When colors are paired with the concepts that evoke them, we call these 'semantically resonant color choices.'" Lin and Heer, "Right Colors."

ued to increase, the two-colored light no longer reduced risk to an acceptable level; city streets filled and overflowed with onrushing cars, bicycles, carriages, and pedestrians, causing a surge in traffic fatalities. A decade later, when every major U.S. city and many small towns had at least one traffic light, the amber light was added to the red/green traffic signal.[20] The amber light is designed to reduce risk within the congested and fast-paced spaces of capitalist circulation. Like the traffic cone, it aims to impede circulation as little as possible, using the smallest possible investment in public infrastructure.

While Americans may associate the amber light with the color yellow rather than orange, the amber light best manifests orange's neoliberal logic of warning: it says *proceed at your own risk*. An invention of the Motor City, the amber light normalizes danger in the name of continued circulation, allowing cars to move through space with as little interruption as possible. Circulation itself—the precondition for capitalism—is represented by the car, which began as a symbol of American individualism and progress in the twentieth century and now, in the twenty-first century, emblematizes U.S. urban blight and climate crisis. But here driving is not simply a metaphor for the existential threat posed by global warming. It is our cultural insistence on traveling by car—the unchallenged supremacy of the auto industry—that, as Andreas Malm argues in *Fossil Capital,* has contributed to "'carbon lock-in': a cementation of fossil fuel-based technologies, deflecting alternatives and obstructing policies of climate change mitigation."[21] And we have yet to put the brakes on our dependency on fossil fuels: as of 2019 we were "burning 80% more coal than we were just in the year 2000."[22]

Like the amber traffic light, maps and other visualizations tracking COVID-19 risk levels use Safety Orange to keep people circulating under the banner of prudence. In these visualizations, Safety Orange is less a gradient of red than it is a *strategic forestallment* of

20. Lin and Heer.
21. Malm, *Fossil Capital,* 7.
22. Wallace-Wells, *Uninhabitable Earth,* 197.

red. During the coronavirus crisis, the visual vernacular of orange in data visualizations has been deployed to disguise imminent danger as potential risk; when the dangerous seems normal, citizens get back to work and capital circulates unimpeded.[23] Now, orange is not the new black but "the new normal," that newly ubiquitous phrase that, like the orange on the data visualizations, normalizes the current situation. When used by governments and corporations, it encourages a worldview that assimilates extreme events as everyday parts of life as a mantra for getting back to business.[24] But this situation is decidedly *not* normal—is anything but normal. This state of emergency, which we experience not as active terror but as exhaustion, as burnout, as anomie, feels as though it is just how things are now—as though it is permanent.

Eventually, though, the elasticity of orange gives out. By late November 2020, White House Coronavirus Task Force member Dr. Deborah Birx was forced to admit that over half of the United States had moved into the "red zone."[25] By December 2020, the country had driven off the cliff of red. With no more room on the barometer, data experts were left with no other choice than to introduce a new color to signify unprecedented levels of danger, and the U.S. turned eggplant on the world map.[26]

23. Indeed, some Republican officials in the United States, notoriously Texas lieutenant governor Dan Patrick, have openly defended sacrificing lives in order to save the economy.

24. See Cox, "COVID-19 and the Corporate Cliché"; Asonye, "There's Nothing New"; and Munger, "Avoiding Dispatches from Hell," 120. For examples of how this phrase has been incorporated into COVID-19 public health messaging, see North Dakota's COVID-19 Smart Restart County Analysis (https://ndresponse.gov/sites/www/files/documents/covid-19/ND%20Smart%20Restart/Additional%20Resources/NDSmartRestartPlan.pdf) and Dallas County, Texas's, COVID-19 Risk Level (https://www.dallas-county.org/covid-19/).

25. The White House Coronavirus Task Force has also adopted the dark green to red spectrum, which by November was effectively yellow to red. Whyte, "Red Zone."

26. Here I am discussing the New York Times coronavirus world map, which was created with online map developer Mapbox and uses data

According to the logic of the original coronavirus data visu-
alization, which went from white to orange, purple should have
been impossible. By resetting the outer boundary of the color scale
from red to dark purple, the data visualization breaks the measure
by which the data's severity can be comprehended. When red no
longer marks the outer limit, we find ourselves in a data field of
undefined parameters where unheeded warnings appear to yield
no visible consequences, only more latitude.[27] Indeed, the visual-
izations' collapse into eggplant subsumes red and purple under
the logic of orange. It suggests not that we are beyond orange but
that the entire color spectrum now only reads as different shades
of orange (including, with corporate "greenwashing" tactics, even
green!).[28] The risk index, invented to make risk thinkable, has the
unintended effect of training us to accommodate and accept un-
thinkable levels of risk: by containing risk within a set limit, it in
effect gets rid of the limit. Red—the color of the revolution, the

from local governments, The Center for Systems Science and Engineering
at Johns Hopkins University, National Heath Commission of the People's
Republic of China, and World Health Organization (available here: https://
www.nytimes.com/interactive/2020/world/coronavirus-maps.html).

27. The data visualizations' shift from a stoplight color scheme to a
rainbow color scheme scale carries a logical pitfall: the scale is effectively
circular because the colors at the beginning and the end are nearly the
same. Wilke, "Common Pitfalls of Color Use." David Borland and Russell M.
Taylor observe that the use of the rainbow color map in data visualizations
"confuses viewers through its lack of perceptual ordering, obscures data
through its uncontrolled luminance variation, and actively misleads inter-
pretation" ("Rainbow Color Map (Still) Considered Harmful," 14).

28. Greenwashing describes attempts to give the false impression to
the public that a company's products are more environmentally sound than
they really are. Dahl characterizes it as "the practice of making unwarrant-
ed or overblown claims of sustainability or environmental friendliness in an
attempt to gain market share" ("Green Washing," A247). Greenwashing has
become more common as more consumers demand greener products and
services; according to a greenwashing report from advertising consultancy
TerraChoice Environmental Marketing, he says, the number of products
making green claims has risen by 79 percent over the last two years (A247).

color of the stop sign—no longer signifies finality; it is only another step in the never-ending intensification of risk.

Orange signals "proceed with caution" but never "stop." Safety Orange makes the current system *seem* like it works as it should. It uses the visual rhetoric of attention and protection to make structural problems appear, not only local or short-term, but also controllable and under control. The absorption of all colors under orange effectively disarms efforts to enact serious systemic solutions to long-term problems. Orange has become the essence of a semiotic warning system that, paradoxically, teaches us to ignore the signs of danger. The strange infolding temporality of orange thus problematizes the structure of "the event" of crisis: as Lauren Berlant contends in *Cruel Optimism,* "slow death" complicates "the ways we conceptualize contemporary historical experience, especially where that experience is simultaneously at an extreme and in a zone of ordinariness."[29]

As Tobias Menely and Margaret Ronda have shown in an essay on the critical and ecological significance of red, there is a long history of ignoring the catastrophic consequences of carbon-based global capitalism represented by the color.[30] Red "serves as the acute sign of apocalyptic revelation itself," making visible "an otherwise invisible threat, much as a stop sign warns of danger."[31] However, they say, red often goes unheeded, because its referent is often invisible (think greenhouse gases, or for that matter, coronavirus): their triggers offer no spectacle, no definite beginning or ending.[32]

29. Berlant, *Cruel Optimism,* 96.
30. The severe warning blared by the color red putatively denotes a crisis that requires action. Menely and Ronda write: "Rather than respond to these grave emergencies, the U.S. government expends its resources in hyperactive scrutiny and prosecution of those who seek to draw attention, under the sign of red, to the increasingly catastrophic work of the free market" ("Red," 38).
31. Menely and Ronda, 37, 24.
32. According to Menely and Ronda, "Red returns yet, however insufficiently, at the edge of the symbolic order. This said, the defining material

Orange is thus inherently inadequate to represent what Rob Nixon calls "slow violence": "To confront slow violence," he argues, we must be able to "plot and give figurative shape to formless threats whose fatal repercussions are dispersed across space and time. The representational challenges are acute, requiring creative ways of drawing public attention to catastrophic acts that are low in instant spectacle but high in long-term effects."[33]

Using orange as a heuristic allows us to make slow violence representable. Perhaps more importantly, it helps us apprehend the *acceleration* of slow violence and death on a mass scale under contemporary conditions. In early 2021, as the United States was marking the grim milestone of a half million deaths from COVID-19, the Centers for Disease Control and Prevention reported that, based on findings from the first six months of 2020, average life expectancy estimates in the United States had dropped a full year—the largest decline since World War II killed a generation of young soldiers. The report found that there were significant racial disparities: Black and Latino death rates were far higher, declining by 2.7 years and 1.9 years respectively, and Black men saw a decline of 3 years.[34] This dry, technical public health report allows us to feel and apprehend the threat to Black and Brown life. Here, orange highlights the extreme inequality of neoliberal policies' effect on certain communities, which become visible in citizens' differential access to health, social and ecological safety, and a secure future. These raw figures evidence the unspectacular loss of communities turned red that COVID-19 risk indexes do not capture. They remind us that, as with all probabilities, the data is based on what has already happened— lives already lost, in this case due to structural failures to act.

conditions of our historical present remain almost entirely unavailable to such disclosure. Of the mostly invisible by-products of industrial capitalism, the most consequential, if among the least conspicuous, are the greenhouse gases, primarily carbon dioxide and methane" (37).

33. Nixon, *Slow Violence,* 10.

34. Arias, Tejada-Vera, and Ahmad, "Provisional Life Expectancy Estimates."

As the "acceptable" margin of loss of life and environmental cost is integrated into the data model, a perpetual state of orange is the indicator of abiding system failure, of warnings gone unheeded, as by design. To return to the problem of climate change: consider the Climate Clock, which as of September 2020 has been conspicuously displayed in orange as part of the public art installation *Metronome* on a building in Manhattan's Union Square. Inspired by the Doomsday Clock, artists Andrew Boyd and Gan Golan imagined the countdown as a way to illustrate the urgency of the climate crisis: the installation counts down the closing of the critical window for achieving zero emissions and preventing global warming from becoming irreversible.[35] The scientific consensus is that we must keep warming under the 1.5°C threshold, beyond which it is widely predicted to wreak damage of cataclysmic proportions, including drought, floods, food shortages, extreme heat, sea rise, hurricanes, and the end of coral reefs, putting hundreds of millions of people into poverty and creating a refugee crisis.[36] As of this writing, the digital clock shows *6 yrs 149 days 17 hrs 41 mins 52 secs.*[37] The work has been described by its creators as a "permanent" public artwork (an ironic description, given its announcement of imminent threat).[38] The irony of being locked in the limbo of permanent imminence is further exacerbated by the material conditions of the public artwork's existence. Its patron is billionaire real estate mogul Stephen Ross, a frequent investor in sustainable cities and the developer who owns the building One Union Square South on which the countdown is displayed. Despite championing the project as one that "will remind the world every day just how perilously close

35. See also the Climate Clock website: https://climateclock.world/.
36. The Climate Clock is calculated by Mercator Research Institute on Global Commons and Climate Change. The clock's creators cite the Intergovernmental Panel on Climate Change's (IPCC) landmark 2018 *Special Report on Global Warming of 1.5° C,* which made these findings: https://www.ipcc.ch/sr15/.
37. The Climate Clock showed this countdown as of August 4, 2021.
38. Moynihan, "New York Clock."

we are to the brink," Ross was a generous supporter of Trump, who ignored scientific evidence and climate activism and aggressively rolled back environmental protections that regulated industrial emissions; the U.S. is now second only to China in global emissions.[39] The greenhouse gas pollution from Trump's policies—in addition to the rollbacks on emissions policies, he passed protections for the fossil fuel industry—has already caused irreversible damage, for over Trump's four-year term in office, we "crossed a long-feared threshold of atmospheric concentration."[40]

As I write these words, the sun is setting on an orange-tinted presidency, and there is good reason for optimism. Vaccination is well underway, a sweeping COVID-19 relief bill has been signed into law, and the Biden administration has begun reversing Trump policies and, thanks to sustained pressure from activists, advancing what have been described by many progressives as solid climate justice and public infrastructure agendas. But even now that Trump has left office, we must not be too quick to celebrate the end of the Orange era in U.S. presidential politics. We should remember that, as a semiotic and linguistic grammar, orange forecloses *both* the rhetoric of extreme danger (the red of catastrophe) *and* the possibility of radical alternatives (the red of revolution). We must remain wary of the tepid glow of a Biden presidency won on a nostalgic reassurance of continuity—the same "sustainability" that underpins the logic of orange. "At first, Biden ran a wobbly campaign as a centrist, a meliorist, open to such reforms as an expansion of the Affordable Care Act and a reassertion of such international accords as the Iran nuclear deal and the Paris climate agreement," writes David Remnick. "But, unlike his opponent Bernie Sanders, Biden would never use 'revolution' or 'movement' to describe his intentions. Having spent more than forty years in Washington, he entered the field hoping to be a candidate of restoration, compromise, and

39. Moynihan.
40. Davenport, "What Will Trump's Most Profound Legacy Be?"

reassurance, a return to some indefinable form of 'normal.'"[41] Even as Biden appears in his early days in office to be embracing a bolder vision for change, there is still much work to be done to prevent worse fallout, and we must not falsely equate continuity with safety. As with climate change, proceeding with caution facilitates disaster: as Naomi Klein has argued, "We don't have to do anything to bring about this future [of climate disaster]. All we have to do is nothing. Just continue to do what we are doing now. . . . And then, bit by bit, we will have arrived at the place we most fear, the thing from which we have been averting our eyes. No additional effort is required."[42] With flashing red warnings of system failure, even in the face of full-blown eggplant, the United States simply can no longer afford to renew its commitments to a capitalist baseline of orange.

41. Remnick, "The Biden Era Begins."
42. Klein, *This Changes Everything,* 4.

3. An Infrastructural Band-Aid: Outsourcing State Accountability

LET US NOW MOVE FROM flashing warnings of existential catastrophe to those more banal and easily overlooked warnings—orange for system failure—that are built into our public infrastructure. Used in public signage, Safety Orange functions as a technology of neoliberal control that trains citizens to be perpetually vigilant and responsible for their own safety and well-being. We can glimpse this logic—which shifts the onus of compliance from institutions onto individuals—in something as ordinary as Slippery When Wet signs. When these signs *hang permanently* instead of being temporarily placed to indicate that the floor has just been mopped, their semiotic function is subtly but significantly altered. Rather than call attention to an actual danger, they render chronic the management of potential risk, outsourcing it to everyone and no one in particular. Like the antismoking campaign slogan Smoking Kills, the warning Slippery When Wet functions as a neoliberal performative; it states a platitude so self-evident as to appear unremarkable, and it thereby surreptitiously contracts everyone present into accountability.

The phrase Slippery When Wet is delivered in the voice of public administration, which, as media historian Lisa Gitelman observes, "reventriloquizes the impersonal authority that has so long hailed and conscripted its subjects to the mediated public: 'post no

bills'; 'all circuits are busy'; 'stay tuned for more.'"[1] But precisely *unlike* an administrative address that says "all circuits are busy," Safety Orange's address does not convey real-time facts or updates. Instead, it operates like road signs that say Be Prepared to Stop or Slow When Workers Are Present; these signs do not inform the driver *that workers are present* but, by interpellating the driver in the conditional mood, make her accountable (indeed liable) for all possible scenarios. The power of these signs is less panoptic than *ambient,* conscripting all who stray into the purview of the sign.[2] As public and commercial spaces are increasingly regulated under the terms of neoliberal management, this semiotic responds-without-responding to what tort law refers to as a duty of reasonable care to protect against known or reasonably foreseeable risks: via passive signage, the public steward or proprietor meets their minimum legal obligation to their patrons and employees even as they demonstrate relative indifference to their fates. If the risk is actualized, it is not the proprietor's fault ("you were warned"); if it is not, it is evidence of the effectiveness of the sign. The felicity of the performative, perversely, can never fail.

These text-based warnings begin with a hypothetical scenario and conclude with an appropriate behavioral response (*If* floor is wet, *then* walk with care; *if* workers are present, *then* reduce speed). While it follows the principle of these signs, Safety Orange differs insofar as it belongs not to a textual but to a visual semiotic

1. Gitelman, *Always Already New,* 131–32.
2. While it is beyond the scope of this book, changes in digital contract law have helped to legitimize new norms of user accountability, which are slyly built into software tweaks sold as improvements. Digital software contracts often leverage mere presence to stand in for consent or legal answerability in user agreements; some user agreements posit "seen" as "signed." Such agreements shift the procedures of the contract from the act of reading and agreeing merely to seeing. Similarly, "read receipts" instill a sense of social obligation simply by virtue of a user being present: once exceptional (and optional), messages that tell a user when something has been "Seen" are now ubiquitous, conditioning a feedback loop of call and response from which it can be difficult to opt out.

system. Orange maintains a similar syntactical structure but proffers a far vaguer relation between the signifier and its referent. It leaves the passerby to fill in the blanks, conveying roughly: *If* [potential danger], *then* respond safely. This untethering of the warning sign from what it refers to matters because it turns the entire landscape into a field of potential danger whose meaning the passerby alone is left to decipher.

This outsourced and distributed form of governance suffuses what Gilles Deleuze termed the regime of control. In *Protocol,* Alexander Galloway shows how this decentralized management associated with the rise of networked technology extends into the street. Galloway contrasts the speed bump with the road sign, arguing that while both are effective means for preventing speeding, they represent two different modes of power. The road sign addresses a logical subject, who makes the conscious decision to slow down, while the speed bump produces a "protocological" subject who subconsciously *wants* to slow down (to protect his car or his comfort): "the signage appeals to the mind," Galloway observes, "while protocol always appeals to the body."[3] In other words, protocol bypasses the moment of decision by installing an infrastructure that subliminally programs the driver's behavior. Insofar as Safety Orange is a signifier detached from any specific signified, orange can be said to be protocological. Yet unlike protocol, orange does not simply manage bodies; it manages expectations. Orange follows Chun's articulation of the workings of new media: it interpellates subjects as decision-makers, withholds information needed to make informed decisions, then holds subjects responsible for the outcome of their actions.

Orange thus operates neither fully logically nor protocologically; while the speed bump subconsciously addresses the body and the road sign consciously addresses the mind, orange blurs the somatic and the semantic, creating an affective field of interpellation. It

3. Galloway, *Protocol,* 241.

does not say *Stop!, Go!,* or *Slow down!,* but instead *Proceed at your own risk.* The logic of the road sign is structural; the logic of the speed bump is infrastructural; the logic of the orange traffic cone is *parastructural.* Where the road sign consciously addresses the decision-making of the driver and the speed bump subconsciously addresses the decision-making of the driver, the traffic cone *affectively* addresses the decision-making of the driver. Pertaining neither strictly to the semiotic logic of the stop sign nor to the somatic logic of the speed bump, the traffic cone manifests a higher degree of contingency and therefore a looser causal relationship between the sign and what it signifies.[4] It simply sits beside the pothole.

Safety Orange is a neoliberal Band-Aid, an alibi that stands in for engaged governance. Invented to convey caution from a distance, the traffic cone literally becomes the guard rails for absentee state infrastructure, as drive-thru COVID-19 testing sites across the country, striated by countless traffic cones, illustrate. Like the traffic cone, Safety Orange is a visual stopgap for structural action. It both encodes and makes hypervisible the retraction of the welfare state and the defunding of public works. Orange does not seek to ameliorate problems but to anticipate and outsource them—to automate governance by training citizens to regulate themselves, to simply avoid the pothole. This is the dynamic in play when states urge citizens to buy generators, anticipating power outages from weak or overloaded power grids during extreme weather events, or to buy their own bottled water as a workaround for failing water systems. As Dean Spade has argued of community-based networks of "mutual aid" (practices of collective resource sharing in the face of state infrastructural failure, malfeasance, and even overt sabotage of its citizens), there is a curtain drawn across the empty place

4. Compared to the traffic sign and speed bump, the information conveyed by the traffic cone is more implicit, ambient, and environmental. By demanding a wider field of attention, it may create greater difficulty in recognizing the cause of the interpellation and the nature of the information being communicated.

that should be filled by concrete climate policies, infrastructural investment, care networks, and other institutional resources; that metaphorical curtain is Safety Orange.

As Cris Shore shows, the de-responsibilization of the state is coeval with the rise of risk society, which he explicitly links to "the politics of neoliberalism and government attempts since the 1980s to render individuals responsible for duties and risks that were previously considered responsibilities of the state or government authorities."[5] It is the careful reallocation of responsibility to the localized, individual level, Shore argues, that allows private companies and government bodies to shed responsibility for large-scale disasters. And as Masco shows, the divestment in local and national infrastructures went hand-in-hand with a deep investment in the technologies of the security state-military infrastructures and the project of counterterrorism. The existential terror on which this project feeds, writes Masco, "not only empowers the most radical actions of the security state; it also creates ideological barriers to dealing with a vast set of everyday forms of suffering and vulnerability that Americans experience, now rejected in favor of warding off imagined catastrophes." According to Masco, these "everyday forms of suffering" include "poverty, bankrupt municipal governments, spectacular white-color crime, energy scarcity"—all of which increase citizens' precarity as the state abdicates responsibility for them, reminding us that what really matters is national security.[6] Safety Orange is the weakest form of care in a postwelfare society that is no longer actively concerned with protecting and improving the lives of its citizens.

The landscape turns orange when the state abandons its citizens, leaving in its wake crumbling infrastructures and mass precarization. Perversely, the state's withdrawal is palliated by a skim of democratic participation and individual agency, which is, of course,

5. Shore, "Audit Culture and the Politics of Responsibility," 100.
6. Masco, *Theater of Operations*, 2.

nothing but a neoliberal ethics of self-responsibilization in disguise: "The human beings who were to be governed [are] now conceived as individuals who are to be *active* in their own government," Nikolas Rose observes. "And their responsibility [is] no longer to be understood as a relation of obligation between citizen and society enacted and regulated through the mediating party of the State; rather, it [is] to be a relation of allegiance and responsibility to those one care[s] about the most and to whom one's destiny [is] linked"—in other words, the relation of individual to individual rather than of individual to society.[7] Orange proliferates as the state surreptitiously transfers responsibility to the citizen under neoliberal information capitalism. As Wendy Brown puts it, "The idea and practice of responsibilization—forcing the subject to become a responsible self-investor and self-provider—reconfigures the correct comportment of the subject from one naturally driven by satisfying interests to one forced to engage in a particular form of self-sustenance."[8] In the absence of a government willing to fill social and economic potholes, the individual must govern herself to avoid the dangers that are everywhere marked by Safety Orange.

The state, however, is far from absent when it comes to nonwhite lives and communities—indeed, it is dangerously present, ever surveilling, ever intervening to punish rather than protect. In light of this, we must reassess the traffic cone. Tou Thao, one of the four officers who were on the scene when George Floyd was murdered, later characterized his role to investigators as that of a "human traffic cone." His sole focus during Floyd's murder, he claimed, was to maintain crowd control by preventing increasingly concerned bystanders from intervening, while fellow officer Derek Chauvin pressed his knee against Floyd's neck for nearly ten minutes. The traffic cone can no longer be seen simply as an emblem of state divestment; this is too kind to the state, for in this figure, the state

7. Rose, "The Death of the Social?," 330, emphasis in original.
8. Brown, *Undoing the Demos,* 84.

is dispassionate and egalitarian, withdrawing resources from all citizens impartially. In fact, the state is heavily invested in protecting the interests of certain groups. We must also think of the traffic cone as an emblem of the falsely impersonal role claimed by the state in its extralegal campaign of anti-Black terror and violence.

Thao described himself as a traffic cone—a mere object, a cog in the machine of the state rather than an actively complicit agent in state violence—to minimize his responsibility for Floyd's death.[9] As Thao's defense makes manifest, the traffic cone that appears to index mere negligence is in fact a symptom of the state's conscious imperative to protect and serve the interests of white supremacy through the continued harm of poor communities of color. Some traffic cones are present to draw attention to holes that will eventually be fixed; other cones are there to impel passersby to simply avoid holes that were never meant to be fixed.

9. Associated Press, "Ex-Officer Told George Floyd Investigators."

4. Orange Is the New Profiling Technology

IN CHAPTER 3, I explored how Safety Orange highlights (even as it purports to compensate for) the shrinking of the state mandate to care for its citizens under the neoliberal order. But, as I argued, the standardized use of orange falsely presumes that all subjects are interpellated alike. Precisely because it is so ubiquitous it seems universal—to speak to everyone in the same way—and its differential effects tend to be obscured. While orange indexes the withdrawal of state attention in certain spheres, it also indexes the state's overattention in others—specifically, in the overpolicing of poor communities of color. The state disproportionately fails to provide resources to these communities, while it overinvests in their surveillance and incarceration. Safety Orange's capacity to mark subjects as dangerous is deeply familiar to those most vulnerable to the abuses of U.S. state power. Indeed, the feeling of chronic crisis signaled by orange, the sense of never-ending high alert and imminent danger, has often been the experience of Black and diasporic, immigrant, and refugee communities of color living in the U.S.[1]

1. As Michael C. Dawson and Megan Ming Francis argue: "Instead of a permanent destabilization of the infrastructure of Jim Crow, neoliberalism has facilitated a rebirth of two of its flagship elements: race-based crime policies and economic exploitation" ("Black Politics and the Neoliberal Racial Order," 34).

In this chapter, I explore how the *exceptional* temporal logic of Safety Orange binds various projects of American imperialism, most prominently the exponential growth of the prison-industrial complex and investment in local law enforcement, the militarization of the U.S.-Mexico border, and the blanket expansion of post-9/11 surveillance protocols. By permanently installing a warning in principle meant to be temporary, the color has been used to deflect the structural racism on which is premised the project of American securitization (of keeping the homeland and its citizens safe). Associating orange with safety elides how the very notion of safety makes some subjects especially vulnerable to state-sanctioned violence—and how the color has been used as a profiling technology that flags bodies precisely for such violence. Orange encodes the process by which, as Mimi Thi Nguyen observes, "the gangbanger, the undocumented person, and the terrorist are rendered knowable through visible signs and screens *fully schematized by racism*."[2] In Safety Orange we glimpse the racial logics that undergird the twin projects of U.S. militarism and securitization at home and abroad: the color helps us see how with the post-9/11 rise in racial profiling, the U.S. security state has been ever more deeply entangled with the carceral state.[3]

Consider the iconic orange jumpsuit. While orange is not the color standard for all prison uniforms, it is the color that signifies "prisoner" in the public imagination, and it is used as a shorthand for incarceration in film and television, such as in popular shows like *Orange Is the New Black*.[4] In the 1970s, prisons began to use

2. Nguyen, "The Hoodie as Sign, Screen, Expectation, and Force," 801, emphasis in original.

3. As Ronak Kapadia has put it, these "intersectional systems of power and violence . . . fuel the ideological engines that legitimate the homeland security state's use of global prisons, confinement technologies, overt killing, and permanent warfare as inevitable features of a political economy that seeks to 'solve' our multifarious contemporary crisis" (*Insurgent Aesthetics*, 11).

4. Beam, "Orange Alert." In California, for example, people who are incarcerated must wear orange or red when they're being transported

orange uniforms for incarcerated individuals in special detention situations—in temporary facilities or during transit—to mark a deviation from the norm and flag the wearer for extra surveillance.[5] By the 1990s the U.S. prison system had introduced orange jumpsuits into regular use.[6] After 9/11, these same orange jumpsuits were worn by Guantánamo Bay detainees, as seen in photos released by the U.S. military. These photos blazoned Safety Orange across international newspapers and televisions, where it telegraphed globally the American state of exception: "Transmitted to the world, the orange jumpsuit was offered by the Bush regime as proof of 'normal' American punishment procedures in, what was put across by politicians as, a justifiably 'exceptional' situation."[7] In the jumpsuit, Safety Orange is a symbol for conscripting subjects into American imperialism's hegemonic power.[8] That symbol has, in turn, been weaponized by foreign militants who dress U.S. citizens in orange jumpsuits before executing them on film.

What does orange's use as the shared code between ostensibly discrete domestic and international security apparatuses reveal about the nature of neoliberal governance? What we find in both is orange's tendency, discussed in chapter 1 as encoding a state of perpetual risk, to present permanent measures as temporary. The orange jumpsuits at Guantánamo Bay encapsulate the suspended temporal logic of the U.S. security state,[9] which holds "enemy

(ibid.). On the enormous significance of color in U.S. prisons, see Fleetwood, *Marking Time,* 43.

 5. Beam, "Orange Alert."

 6. Ash, *Dress behind Bars,* 4.

 7. Ash, 4.

 8. Ash, 159.

 9. Another example of this is the traffic cone's steroidal cousin, the New Jersey barrier, which architecture historian Trevor Boddy calls "the first visual icon of the Homeland Security era." Boddy explains that the barricade's "presence was a response to 'an instant need for the symbolism of war—something needed to be seen to be done.'" Boddy observes that in 2002 and 2003, New Jersey barriers became ubiquitous in the Washington, D.C. city landscape: "They were the visual analogue of the rhetoric of the

combatants" indefinitely, with no promise of resolution: detainees may neither be returned to their home countries nor charged, nor even executed. Guantánamo has become the paradigmatic site of the U.S. state of exception—the law that authorizes the suspension of the law in the case of an emergency. In Guantánamo we see that the emergency never ends. Orange is a reminder that the War on Terror is never over, it is always at Threat Level Orange.

The U.S. War on Crime, too, is never-ending—another permanent state of emergency. Indeed, in the aftermath of 9/11, Angela Davis invoked Guantánamo Bay to argue that the U.S. prison serves a similar ideological function in the public imagination "as a fate reserved for others"—or for "evildoers," to use the term popularized by George W. Bush: "an abstract site into which the undesirables are deposited, relieving us of the responsibility of thinking about the real issues afflicting those communities from which prisoners are drawn in such disproportionate numbers."[10] In both contexts, the state of exception is spatially and temporally literalized, with prisons and Guantánamo occupying "abstract sites" for indefinite periods of time. The prison-industrial complex grew exponentially in the 80s and 90s, Davis observes, as the prison changed from a short-term tool for behavioral correction to a permanent holding pen, a place to indefinitely stash Black and Brown bodies marked as "dangerous." It is in this context that the orange prison jumpsuit emerged—a technology of punishment through which to shame and objectify the racialized incriminated and incarcerated body, to mark it out for heightened discipline and surveillance.[11]

In the domestic U.S. context, orange's equivocality—its ability to dress endangerment up as protection—plays out in the legal and policy discourse addressing "at risk" populations. In principle, this

war on terror, a concrete icon inserted into the city to sustain the 'all is changed' sense of unease amongst law-makers, lobbyists and the media" ("Architecture Emblematic," 278).

10. Davis, *Are Prisons Obsolete?*, 16.

11. Van Veeren, "Orange Prison Jumpsuit," 124.

label is meant to identify populations most in need of support and resources, to flag them for additional care. In practice, it has often been turned against these communities, which are largely communities of color. "At-risk" means "risky," a future threat ("Code Orange"), legitimating the use of extreme forms of state violence against them: surveillance, police harassment and brutality, incarceration, and death—campaigns tantamount to state-sanctioned terrorism. The social construction of the "at risk youth," observes historian Elizabeth Hinton, was key to advancing the federal law enforcement programs (such as the Reagan Administration's Antidrug Abuse Act) that laid the groundwork for the mass incarceration of African Americans.[12] Impoverished neighborhoods were framed as posing sustained levels of threat—as "high risk zones," where "low-level crimes and misdemeanors created an atmosphere of disorder." This legitimized preemptive state responses that would contain the putative threat:[13] police programs like Stop-and-Frisk and predictive policing algorithms like PredPol, which treat poverty and race as predictive of threat. These preemptive technologies justify the criminalization, racial profiling, and further oppression of marginalized communities,[14] pushing vulnerable, "at-risk" popula-

12. As Hinton has shown, the Reagan administration's fight against the drug trade and traffickers focused on "high risk youth," "defined as children from low-income households, runaways, drop-outs, products of dysfunctional families, and juveniles in the criminal justice system" (*War on Poverty*, 320–21)—in other words, a code for young Black men. This strategy helped the administration pass the Anti-drug Abuse Act, signed in 1988.

13. O'Neil, *Weapons of Math Destruction*, 87.

14. O'Neil, 85–104. Wang points to the central role played by algorithmic prediction in carceral capitalism. Just as financial operations increasingly rely on one's credit score, invoking one's future behavior to sanction decisions about the present, so too does policing rely on this strange temporality of prediction; it is "no longer primarily aimed at effectively responding to crime, but at *anticipating* and *preventing* it" (*Carceral Capitalism*, 42, emphases in original). Even though it has been shown on numerous occasions that "predictive tools often enshrine bias because they use datasets that are themselves tarnished by racial bias" (50), bankers and police hide behind the apparent objectivity of algorithms, denying loans to or targeting for enforce-

tions into the ambit of the prison; since 2002, Stop-and-Frisk alone
has resulted in over five million stops and street interrogations, 90
percent of which targeted Black or Latino people.[15] The racialized
surveillance enabled by the rhetorical slide of "at risk" from "in
danger" to "a danger" has been made highly visible in responses to
the coronavirus pandemic: social distancing guidelines are enforced
unevenly, with police sometimes violently arresting people of color
for not wearing masks while giving white antimaskers a pass. These
enforcement patterns, which treat people of color as posing a higher
risk of spreading the virus, further compounding the virus's already
disproportionate impact on communities of color.

Orange can thus signify either privilege or lack of privilege, as
its referent changes with the color of the body that wears it. It can
signify either state recognition and care (firefighters' uniforms, road
workers' safety vests) or state regulation and surveillance (prison
jumpsuits). Occasionally, the color designates both protection and
warning at once. Recent reporting on the historic wildfires that
ravaged the West Coast show California inmate firefighting crews,
suited up in orange uniforms, battling on the front lines for only a
few dollars a day, under a sky turned orange.[16] Such examples of
the equivocality of orange make clear that those subjects construed
as most risky are the first to be sacrificed in the name of collective
well-being.

But Safety Orange's hypervisibility can go both ways. When ISIS
militants responded to Guantánamo by executing U.S. citizens on
camera in orange jumpsuits, they repurposed the symbol—drawing

ment those racialized populations who have historically been subjected to
heightened scrutiny. Algorithmic prediction, Wang notes, operates as a self-
fulfilling prophecy that perpetuates racial stereotypes: "in marking subjects
as potential risks, they are actually produced as such" (43).

15. NYCLU, "Stop-and-Frisk Data."

16. California's Conservation Camp Program has itself been described
as a "cheap and exploitative salve" for escalating environmental crises that
replaces proper investment in public infrastructure. Fuller, "Coronavirus
Limits California's Effort."

attention to the invisible work being done by the hypervisible color. Similarly, the same Safety Orange that marks out certain bodies for racialized surveillance has been used to draw attention to the legacy of state racism that underpins carcerality: A number of African American contemporary artists and performers have employed the color to highlight the routinized surveillance of Black bodies and systemic racial violence in America.[17] David Hammons's *Orange Is the New Black* (2014–15), for example, presents a series of pastiched African masks and fetish objects, all painted a uniform orange. Hammons juxtaposes the cultural power of these Nkondi sculptures, traditionally protective objects, with the oppressive carceral force of the orange prison jumpsuit to which the work alludes.[18] Cameron Rowland's *1st Defense NFPA 1977, 2011* (2016) features an orange Nomex firefighter suit manufactured by prison laborers forced to work for the California Department of Corrections and Rehabilitation. The work underlines the persistent legacies of the U.S. slave economy in contemporary neoliberal capitalism. Hank

17. These aesthetic strategies parallel the epistemology proposed by McGlotten, who coined the term "black data" to describe an emergent mode of Black aesthetic practice that responds to the reduction of Black queer people, and people of color more broadly, to statistics. McGlotten writes: "Technes of race and racism reduce our lives to mere numbers: we appear as commodities, revenue streams, statistical deviations, or vectors of risk" ("Black Data," 263–86). Interpretive and performative Black queer practices, figured as Black data, refuse to be reduced to bare accounting by engaging in aesthetic projects that foreground illegibility or encryption.

18. Hammons's 2015 career retrospective, *David Hammons: Five Decades,* at Mnuchin Gallery in New York draws a formal connection among works through the repeated use of orange—from *Orange Is the New Black* to an untitled orange tarp draped over canvas to *A Moveable Object,* an overloaded orange flatbed dolly labeled with the caution DO NOT RIDE OR OVERLOAD. The plainly ignored warning is typical of the use of puns and dark humor central to Hammons's practice. The use of orange speaks to Hammons's tendency to work associatively, allegorically, or poetically, rather than didactically—viewers must connect the orange dots between the Nkondi sculptures, the Netflix show, the gallery space, and the carceral state (Hammons et al., *David Hammons*).

Willis Thomas's *We the People* (2015) repurposes decommissioned prison uniforms in a quilt that spells out the democratic incantation opening the U.S. Constitution. In her performance-based video *ORANGE JUMPSUIT* (2019), Cauleen Smith creates an orange floral arrangement the color of prison uniforms, which the artist leaves as a memorial outside of the L.A. County Jail. Finally in the performance-based works *White Room 4* (2015) and *Orange People Are the Grid on the Ceiling* (2012), William Pope.L employs the color orange to emphasize the arbitrariness of the concept of race.[19] These artworks all play on the popular association of Safety Orange with mass incarceration to problematize the implicit and explicit relationship between race and color, as well as to bring attention to the institutions that perpetuate and profit from racial discrimination and violence.

All of these artworks insist that race in America is not only an issue of black and white but also of orange. Through its very abstraction and mobility as a sign, as these artists demonstrate, Safety Orange both distills racial violence, acting as its material trace, and displaces this violence away from the Black body onto a "neutral" color. Mimi Thi Nguyen makes a similar argument—that Blackness does not stop at the limits of the body—in her tour de force article on the racist optics of the hoodie. Nguyen takes the 2012 murder of Trayvon Martin as her point of departure. Before shooting Martin,

19. For example, in *White Room #4/Wittgenstein + My Brother Frank* (2005), Pope.L employs humor and the theater of the absurd by dressing up in a bright orange yeti suit and attempting to rewrite from memory both Wittgenstein's *On Color* and his brother's ideas about power and representation. The performance plays on the connection between color as a formal problem and an investigation of race; color (and thus race) is treated as a "language game," in Wittgenstein's terms. Wittgenstein is concerned with the "logic of color" that is neither a priori nor empirical; in the performance, Pope.L asks onlookers to interrogate "the logic of race" along similar lines. It is impossible to ignore the role of orange as the work's principal visual element, given the formal contrast between the stark white of the room and all the other objects it contains and the bright orange of the yeti suit (Rove Projects, "William Pope.L").

George Zimmerman told the 911 dispatcher that he followed the teenager after becoming suspicious of his "dark hoodie." Nguyen argues that the hoodie surrogates the Blackness of its wearer and his exposure to racist violence.[20] She shows that the hoodie, by virtue of its separability from the body that wears it, offers an alibi for disavowing the racism visited upon its wearer, lending anti-Black violence a form of plausible deniability.[21] Displacing race from body to clothing, the hoodie creates an "ontological confusion between subject and object," and as such "provides cover for racism's slide into lethal structures that claim to assess and predict threat with disinterest."[22] In a terrible irony, the same hoodie that affords Black

20. Almost twenty years before Martin's murder, Hammons made a similar visual argument in his sculptural work *In the Hood* (1993), the hood of a sweatshirt nailed to a wall. The piece plays with language (hoodie, "the 'hood") and the racialized fetish object as both a form of abstraction *and* metonymy.

21. In *Training for Catastrophe,* Thomas has shown how the racist logic of the hoodie operates within the coded visual rhetorics of U.S. Homeland Security training materials. Reading a series of "If You See Something, Say Something" videos, Thomas argues that the campaign signals the very idea of threat by depicting hoodie-wearing anonymous figures—embodiments of an unnamed risk—"whose faces viewers only indirectly glimpse, doing suspicious things like leaving backpacks in public places, breaking into storage units at night, taking pictures of train platforms and writing down the schedules of the security guards patrolling the platforms, and sneakily entering secure areas without authorization" (177). Thomas points out how this material stokes anti-Black violence: "The visual aesthetics of the campaign, combined with how it encourages people to interpret specific objects and actions, reinforces the audience's associations, conscious or not, of suspicious behavior with people of color, especially, through the depiction of people wearing hoodies, with Black people" (181).

22. Nguyen, "Hoodie as Sign," 800. Nguyen writes: "Just as the hoodie renders identification of its wearer more difficult, the hoodie also provides cover for antiblackness. Under such lethal structures and abstractions, the profile is the sensible assessment of risk that conceives misrecognition as an unfortunate consequence. Collateral damage, as it were. To put it another way, the presence of the hoodie in the profile renders what is systemic violence against black life an *accident* understandable as a rational calculation of danger deferring, but not displacing, the fact of blackness in such a calcu-

men a way to resist certain forms of surveillance also marks them for excessive scrutiny and violence. This irony is captured by what Frank B. Wilderson III has called "the cardinal rule of Negro diplomacy": Black subjects, men especially, are expected to make those who regard them as "too black for care" feel safe (a routine familiar in stories of traffic stops: black men who have to reassure the cops who are supposed to protect them that they are not in danger).[23]

Like the hoodie, orange testifies to the *abstractibility* of race; both partake of the same distancing logic, whereby a sign ambivalently gestures toward and away from their referent. Where the hoodie simultaneously marks and masks Black bodies, orange codes people and the spaces they inhabit as both potentially under threat and potentially threatening. But where the racist logic of the hoodie only converts hiding into hypervisibility and self-protection into criminality, Safety Orange might still allow the ambivalence inscribed in its hypervisibility to be redirected as a tool of resistance and solidarity, as we'll explore in the next chapter.

lation. The deferral of certainty (of meaning, identification) via the effacing hoodie provides recognition and misrecognition simultaneously and also supplies the occasion for the deferral of ethical and legal responsibility for targeting black life" (802–3, emphasis in original).

23. Wilderson, *Afropessimism,* 6, 17. "*Make them feel safe,* I had thought to myself, even though I had never felt more at risk" (6, emphasis in original).

5. Orange Applied: Artistic Appropriations

IN THIS FINAL CHAPTER, I turn to artists who seek to use Safety Orange's hypervisibility as a tool of protection and redress, a way to force the state to make good on its promise of public safety. These artists explore whether the violence encoded in Safety Orange— violence rendered routine, uneventful, turned into a chronic crisis— might be used to compel the state to fulfill its duty of care. They ask: Must orange remain an abdication, an eternal traffic cone beside a pothole? Or, alternatively, can the color of warning and state racism be turned against its own logic and used instead to empower communities? However, these questions also pose their own problems. As we will see, many of these artists intervene on behalf of communities not their own, and their works often reflect the difficulty of forging solidarity through orange.

In the mid-2000s, an anonymous group of artists called Object Orange began painting abandoned homes in Detroit "Tiggerific Orange" (from Behr's Disney paint series) to draw attention to the city's pervasive urban blight, which is easily overlooked by those only passing through. For the series of interventions, which they called *Detroit, Demolition, Disneyland* (2006–8), the group chose to paint abandoned houses visible from the highway. They leveraged the visual rhetoric of state oversight to compel a dialogue about state inaction, drawing attention to the neglected houses' negative

impacts on their communities. Among those impacts cited in coverage of the work were the drug use they shelter and the dangers they pose to children who play in the collapsing structures.[1]

By attempting to use the color of state control against itself, the project wields orange as a catalyst, an agent that in and of itself has the power to trigger a reaction. The artists tap into the bureaucratically coded language of orange as a means to force the state to respond. They deploy color as a tactic, much as anti-fracking activists have done by painting and copyrighting trees as works of art in order to halt the expansion of natural gas pipelines.[2] What these undertakings have in common is that they both exploit a right of protection afforded by the legal category of art. For the antifracking activists, the act of painting protects the trees by making them legally recognized as art; for Object Orange, it protects the artists by enabling their work not to be dismissed as mere vandalism and endowing it with a new kind of public significance (as "newsworthy" public art) and thus wider visibility.

Like the multiple valences of paint itself, the equivocality of Safety Orange makes it difficult to control, which allows it to be critically and politically recoded. We find a similar process of recoding at work in how protestors around the world have reimagined the uses of traffic cones beyond their uses as instruments of state control. From Hong Kong to Minneapolis, orange cones have been redeployed as creative tools of resistance, their ubiquity leveraged to challenge militarized state power: they have been used to trap tear-

1. *Detroit Free Press,* "Bright Light on Blight." (Object Orange, *Detroit. Demolition. Disneyland*). One member of the group explains that the artists selected abandoned houses with facades that overlooked major arteries. Before painting the houses, they scouted the sites for several weeks to make sure they were no longer in use (Interview with author).

2. Rahmani and Steinhauer, "Using Art to Stop a Pipeline." Tyree Guyton has done something similar. When the city of Detroit attempted to demolish the Heidelberg Project in the 1990s, the artist responded by legally registering the work as a nonprofit. Agrell, "Detroit a Hotbed of Cool Art?"

gas grenades to contain the gas's spread, to function as makeshift megaphones during large protest gatherings, and to block roads as part of guerrilla public demonstrations.[3] In the former instances, the cone's appropriability is a function of its form; in the latter, it is largely a function of its color.

As a consequence of Safety Orange's flexibility as a sign, at issue in the color is the question of who gets to do the appropriating and on whose behalf. In this regard, the ethics of Object Orange's interventions are hardly straightforward, as the artists themselves recognize. When half of the houses were demolished soon after they were painted, it appeared that the project had successfully forced the hand of the city to make good on then-Detroit Mayor Kwame Kilpatrick's lapsed promise to demolish 5,000 buildings in his first nine months in office.[4] However, the city's response showed the project to be primarily a dialogue between the artists and the city, largely staged for an elite art world and academic audience. Despite Object Orange's good intentions, perhaps because of its status as a public artwork, *Detroit, Demolition, Disneyland* largely speaks past the community on whose behalf it is acting. If the work's viewership has the relative social and financial capital to intervene, what does such an intervention actually *do* for the people who live in these neighborhoods? What are the power implications when primary

3. For use of traffic cone in Hong Kong and Black Lives Matter protests, see Diss, "Hong Kong Protesters Get Creative"; and Ma, Shutler, and Bromwich, "Why Protest Tactics Spread Like Memes."

4. Bello, "Urban Art with a Cause." However, the artists have complicated this outcome; they now say that the group's aim was not to have the buildings torn down but rather to raise awareness of Detroit's housing crisis outside the borders of the communities that bore its brunt (Object Orange, interview with author, May 4, 2021). In an anonymous piece penned by the group, the artists maintained that problems of deindustrialization and suburbanization could only be superficially resolved by demolition and pondered whether reinvestment and renovation might be a better outcome (Object Orange, "Detroit. Demolition, Disneyland").

audiences of the artwork (art critics and collectors, the mainstream press, intellectuals, suburban drivers) are "just passing through"?[5]

Object Orange was inspired by the Heidelberg Project, Detroit artist Tyree Guyton's thirty-five-year effort to revivify his once-neglected block by painting polka dots on vacant houses (an effort not without its own ethical quandaries and considerable pushback from residents).[6] One key difference between the projects is that Guyton has lived in the east side Detroit McDougall-Hunt neighborhood he works in, and the very house he grew up in anchors the Heidelberg Project.[7] Object Orange's success in grabbing the interest of the national press and art world was a short game, as Guyton has pointed out,: "Now that these guys have gotten attention, where do they go from there? That's something you have to think about."[8] Certainly, Object Orange raises difficult questions about the ethics of outside artistic intervention—not least of which: Is it ethical to turn abandoned homes into public artworks? But my point here is not that artists always need to be part of the group on whose behalf they purport to act. Rather, it is that Object Orange, in attempting to put orange to use on behalf of others, makes manifest something important about how the color works: as a sign, orange inherently surrogates itself for, and thus abstracts, its subject. As a result, it can have the inadvertent consequence of exchanging one form of social invisibility for another.

5. As one member of Object Orange admits, "It's fair to say that Object Orange did not do a lot of surveying of various community members. We were interested in putting the work out there.... A dialogue about these things is important and necessary and the goal was to get that started" (Interview with author).

6. For more on the Heidelberg Project and its self-sustaining mission, see https://www.heidelberg.org/. "The HP believes that a community can re-develop and sustain itself, from the inside out, by embracing its diverse cultures and artistic attributes as the essential building blocks for a fulfilling and economically viable way of life."

7. Larsson, "Art of Abandonment."

8. Bello, "Urban Art with a Cause." For a discussion of Tyree Guyton and Object Orange, see Zacks "Orange Alert."

Like Object Orange, Amanda Williams's "Flamin' Red Hots" strategically brandishes color to expose the arbitrary or ambiguous distinction between urban blight and urban beautification. "Flamin' Red Hots" (named after the Cheetos flavor) is part of her year-and-a-half-long *Color(ed) Theory* installation series (2014-6) in Chicago's Englewood neighborhood. Williams, though a trained architect, says she is not interested in *Color(ed) Theory* as an architectural solution or intervention; instead, she is concerned with making visible what is present and not present, and in that case, with highlighting the lack of investment and resources in the neighborhood.[9] She uses color to lift into view the racialized structures of urbanization and gentrification and to visually disrupt the landscape produced by Chicago's discriminatory housing lending practices, calling attention to the double bind of Blackness's simultaneous invisibility and hypervisibility.[10] Orange is only one color in Williams's broader palette, which is "based on hues primarily found in consumer products marketed toward Black people" in her hometown South Side neighborhoods.[11] Williams has said that the socially coded colors she chooses—which include Pink Oil Moisturizer (a light pink), Newport/Squares (a deep blue-green), and Harold's Chicken (an orangey-red)—are rooted in the collective memory and experience of the people who live in the houses she paints.[12] Echoing Pope.L's amusement with the term "person of color," Williams tongue-in-cheekily identifies herself as an "artist of color"—a phrase with a double meaning: she is both a Black artist and a painter whose primary medium is color. Inviting her audience to consider the structuring logic of color at work in processes of urbanization and gentrification ("redlining,"

9. Williams, "Conclusion."

10. Williams observes: "There's not a day that goes by that I don't think about color as both an artistic medium, and then also as race. As an African-American person, color is always in the foreground as a racial signifier."

11. Drew and Wortham, "*Color(ed) Theory*," 134.

12. Sargent, "Amanda Williams' Color Theories."

"white flight," "greenlit" projects, etc.), Williams asks: "What color is urban? What color is gentrification? What color is privilege?"

While Harold's Chicken approximates Safety Orange, Williams has said that she purposely chose not to use the bureaucratic color standard, presumably for its association with state violence.[13] When the artist most pointedly addresses issues of safety and security in *Color(ed) Theory*, she opts instead for bright yellow.[14] Williams appears to entertain deep misgivings about the possibility of repurposing Safety Orange—misgivings, I hazard, likely shared by many of the Black artists whose work I discuss in chapter 4, namely David Hammons, Cameron Rowland, Hank Willis Thomas, and Cauleen Smith (with the possible exception of William Pope.L). How can we explain these artists' seeming reluctance? My guess is that for these artists, trying to repurpose Safety Orange entails accepting the terms dictated by a state founded on and structured by anti-Blackness. Moreover, as a form of state speech, orange functions not in spite of but because of its uncanny capacity to say one thing and its opposite (to mean both safety and danger), while never challenging the ideologies that underpin it. It is precisely orange's capacity to be repurposed that has made it such a useful tool of neoliberal state violence.

Although *Color(ed) Theory* visually echoes the work of Object Orange, the two projects also differ in other important ways. First, the artists who make up Object Orange at the time lived in Michigan but not in the Detroit neighborhoods where they painted; Williams grew up on Chicago's South Side, where her project is rooted. Second, unlike Object Orange, Williams's project uses houses already slated for demolition, and the houses are not painted anonymously, under cover of nightfall; instead, they are painted collectively by residents, making the project more about a community reclaiming a sense of ownership of its surroundings. For Williams,

13. Bianca Marks, representative for Amanda Williams, email to author, February 1, 2021.
14. Dionne-Krosnick, "What Color Is Racism?"

the eventual demolition of the buildings is part of the project, but her main goal is to create space for community reflection about the buildings' demolition (though as of 2017, half of the buildings still stood due to a backlog of condemned houses).[15] *Color(ed) Theory* aims to memorialize the homes rather than erase them, as one could argue of Object Orange.[16] Williams wants people to register a sense of loss, to mourn the casualties of state divestment. However, she dismisses the idea that community members would have a strong response to the project; the reality, she says, is that they are too "desensitized" to care.[17]

Much as William Pope.L's, Williams's use of orange explores the political possibilities of embracing extreme visibility. Like Frank Ocean's iconic album *Channel Orange* (whose bright orange cover captures the artist's synesthetic experience of being in love for the first time) or urban fashion's adoption of hunting and work safety gear (with the popularity of orange-loving brands like Carhartt and Supreme and collaborations by Helmut Lang x Travis Scott and Fenty Puma), the *Color(ed) Theory* series appropriates the terms of visibility by which racialized surveillance operates in order to celebrate pride and pleasure in everyday Black life.[18] Set against these

15. Svachula, "MCA Exhibit."
16. As the art critic Susan Snodgrass observes in her discussion of these works by Object Orange and Amanda Williams, the Berlin-based artist Katharina Grosse's *psychylustro* (2014) is an instructive analog to the time-based aims of these projects. With the support of the City of Philadelphia's Mural Arts Program, Grosse also used bright house paint—in her case, orange, green, pink, and white—to transform rail line corridors running through the city's most impoverished areas, "converting the walls of abandoned buildings, broken fences, piles of rubble and patches of overgrown grass, into sites of momentary beauty and reflection." But where Object Orange and Amanda Williams must grapple with the question of whether its intervention can (or should) invite the lasting effect of demolition, *psychylustro* thematizes the fleeting nature of its impression on the enduring landscape; it is a one-time intervention that will be allowed to fade over time ("Painting as Urban Archaeology").
17. Sargent, "Amanda Williams' Color Theories."
18. See Corsillo, "5 Ways to Wear Safety Orange"; Schimminger, "Sorry

stylistic practices, the series stands in strong contrast with the other projects I discuss in this chapter insofar as it trades Black survival for Black thriving; in its embrace of hypervisibility, *Color(ed) Theory* runs counter to the Black politico-aesthetic projects of undetectability and counter-surveillance articulated by Simone Browne as "dark sousveillance" and Shaka McGlotten as "black data," which seek refuge from the glare of mass surveillance and biometric technologies trained on Black and Brown bodies.[19]

If the art projects I have discussed thus far in this chapter are (at least initially) "additive" in their application of orange, Michael Rakowitz's *A Color Removed* (2015–18) is by contrast decidedly "subtractive."[20] *A Color Removed* is a community-produced conceptual artwork, which proposed to remove all orange objects from the city of Cleveland. Rakowitz, an Iraqi American artist, invited members of the public to donate orange objects as a statement on the safety denied to Tamir Rice, a twelve-year-old boy who was murdered by police in 2014. Responding to a call about a young man with a gun outside of a recreation center in a predominantly African American neighborhood, one of the two responding officers, Officer Timothy Loehman, shot Rice twice in the stomach less than two seconds after the police car door opened. Police claimed that Rice was shot because the toy gun he was playing with was missing

Pantone"; Brannigan, "Spring 2018 Runways Have Spoken"; and Kelleher, "Blaze Orange."

19. Browne, *Dark Matters*. McGlotten, "Black Data."

20. This distinction is also an oversimplification. While Object Orange's and Williams's artistic processes can be characterized as "additive," in the sense of layering paint over existing edifices, both projects are engaged in the problematics of removal. In one interview, Williams observed: "Architecture in certain neighborhoods is marked by a process of removal, *not* addition" (Sargent, "Amanda Williams' Color Theories," emphasis added). Characterizing Rakowitz's process as subtractive runs into the opposing issue; although it is premised on the removal of a color from a city, the exhibition itself amasses those removed objects to fill up the gallery. These contradictions highlight an inverse relationship between these artists' practices and their products. (I thank Dylan Volk for pointing this out.)

the orange plastic safety tip that identified it as a toy; it lacked the orange signifier of harmlessness that would have marked Rice as a child rather than a risk. The officers' claim about the lack of orange was an attempt to deny that their unchecked use of lethal force was racially motivated. It was just an unfortunate accident, they seemed to say; any child playing with a realistic-looking toy gun would also have been killed. The lack of orange, in other words, was used as an alibi for Rice's murder.[21] And this alibi worked, for neither officer was indicted for the killing.

On the far wall of the Cleveland gallery SPACES, the viewer finds a makeshift altar: an orange-framed picture of Tamir Rice, accompanied by a poster reading "He was only 12." Another poster, mounted alongside emblems of a typical American childhood—orange plastic baseball bat, football, and school-issued recorder—reads "He was only a kid playing in a park." The altar, the creation of Rice's mother, Samaria Rice, is surrounded by four traffic cones, a brutally belated refashioning of the danger associated with what Christina Sharpe has called "the apparatus aimed at corralling black life" into a memorial of safekeeping.[22] The traffic cones allude to the disavowed affinity between Blackness and state infrastructure. Black bodies *are* the United States' foundational infrastructure, the elided backbone of the nation's economy since its founding. But Black bodies have instead been treated as a crisis to be managed. Here, the traffic cone bears witness to the hole in Rice's family and community—the empty site of loss brought about by a perpetually broken system.

The rest of the gallery is filled with single-use orange plastic consumer goods and synthetic toys and foods donated by members of the community in response to Rakowitz's call: artificial flowers, cups, coat hangers, parking signs, sleds, sand buckets, Halloween pails, NERF footballs, Play-Doh, Ramen noodle packages, Garfield

21. In the United States, it is required by law that the barrels of toy guns have tips of Blaze Orange, the same color as Safety Orange ("Marking of Toy, Look-Alike and Imitation Firearms").

22. Qtd. in English, *To Describe a Life,* 1.

watches, *Despicable Me* merchandise, Cheetos packets, Tootsie Pops, crayons, and so on. *A Color Removed*'s statement on the state's brutal denial of protection to Black citizens is also an implicit commentary on environmental racism, for the environmental and health impacts of single-use plastics and processed foods fall disproportionately on lower-income communities of color, and particularly on their children.[23] Safety Orange thus signals the structural enmeshment of consumer marketing, poverty, racial inequality, and climate injustice.[24] Safety Orange is inextricable from the wider ecological and necropolitical material economies of toxic petrochemicals, which constitute about 90 percent of all plastics on the market.[25]

23. In his work on the slow violence of environmental racism, Thom Davies has shown that petrochemical pollution is in large part produced on the site of former slave plantations: the lower course of the Mississippi River is home to the densest cluster of chemical facilities in the western hemisphere, with 136 petrochemical plants and 7 oil refineries stretching along 85 miles of riverscape. "Many former slave plantations along the Mississippi were sold directly to petrochemical companies in the mid-20th century, and turned into chemical processing facilities. This exchange of land use—'from plantation to plant'—has exposed local residents, many of whom descend from slaves, to the life-limiting and protracted threat of harmful pollution" ("Slow Violence and Toxic Geographies," 6). In this legacy of endangerment, which trades one form of dispossession for another, one can observe that "the legacy of the slave plantation 'provided the blueprint for future sites of racial entanglement'" (9).

24. Due to the lack of government regulation, manufacturers are not required to list the ingredients of their plastic products or the amounts of synthetic dyes used in foods, and it is impossible to trace the full extent of petrochemicals' presence in these products. For a discussion of consumer transparency and federal regulation of plastics manufacturing, see Freinkel, *Plastic*, 95. The FDA requires food manufacturers to list all ingredients on the label, in descending order of amount, and "certified" color additives like Yellow 6 to be listed by name ("certified" meaning they require continual certification in batches); however, the FDA does not require that the precise amount be listed (U.S. Food and Drug Administration, "Color Additives Questions and Answers for Consumers").

25. Recent developments in the plastics industry (fabrication technologies such as injection molding) mean that these products are inexpensive to produce and can be manufactured at unprecedented rates. Freinkel, 24–25.

Crude-oil based products like traffic cones and plastic toys—the types of products that can be easily manufactured using orange colorants—are typically made from polyvinyl chloride, better known as PVC, the single most poisonous and environmentally damaging of all plastics.[26]

A Color Removed connects American anti-Black racism to global racism, depicting other sites where state violence manifests abroad. The installation includes a video of a mural created in solidarity with Rice by the people of Aida Refugee Camp; the mural memorializes Aboud Shadi, a thirteen-year-old Palestinian boy murdered by an Israeli sniper in 2015. The installation also includes a life vest that was used by a Syrian refugee who drowned before reaching Europe. The wall text for these items explains: "These objects make more apparent the entanglements of *A Color Removed* by drawing connections between the global endemics of racism, dispossession, militarism, and colonialism." Using orange as a common denominator for the incommensurate impacts of colonial, ethnic and racial violence, the artwork seeks to open up a dialogue about the unseen commonalities between those subjects denied the care of the state.[27]

But as a reflection on the limits of solidarity, even as it attempted to initiate a dialogue about the intersectional politics of risk and

26. Petrochemical plastics (including food additives containing Yellow 6) are disproportionately sold to lower-income communities and communities of color, and many of them primarily target children. Since these products are highly durable—one of their selling points—they are non-biodegradable and also require large amounts of chemical pollutants and fossil fuels to manufacture. Their cycle of production, use, and disposal releases toxic, chlorine-based chemicals that build up in the water, air, and food chain, causing severe health problems such as cancer, immune system damage, and hormone disruption (Greenpeace, "PVC"). See also Freinkel's *Plastic* on the particular dangers of PVC and its effects on poor communities.

27. Bins set up around Cleveland to collect orange objects for the artwork were stenciled with these words: "The right to safety is a transnational problem that binds policing, militarization, colonialism, and racism. / Cleveland is Ramallah, / is Ferguson, is Soweto, is Kabul, / is Belfast, is Baghdad, is Standing Rock, / is Sydney, / is Bethlehem . . ."

safety, *A Color Removed* received some pushback from local activists and artists and one scholar close to the project. After some local Black artists and activists criticized *A Color Removed* for failing to include Black people, Rakowitz met with the artists and activists to discuss their critiques of the project. He responded to these concerns by reframing the exhibition as a collaboration featuring the works of four Cleveland-based African American artists who address related themes: Amber N. Ford, Amanda King (as part of the Shooting without Bullets youth photographers collective), M. Carmen Lane, and R. A. Washington of Guide to Kulchur.[28] An early collaborator of the project later dropped out after accusing the work of appropriating the trauma of the Rice family,[29] an accusation Rakowitz (who collaborated with Samaria Rice on the exhibition) strongly refutes.[30] Such critiques of the work resonate

28. Additional collaborators credited include Jeremy Bendik-Keymer, Amir Berbic, Christopher Horne, Elaine Hullihen, Kelley O'Brien, and Anthony Warnick of the Muted Horn, and Samaria Rice & The Tamir Rice Foundation.

29. The ethics professor Jeremy Bendik-Keymer first invited Rakowitz to propose the project as part of a lectureship at Case Western University in 2015. According to Rakowitz, Bendik-Keymer abandoned the project in March 2018 a few months before the exhibition was scheduled to open (Rakowitz, email to author, June 24, 2021). Bendik-Keymer has publicly criticized *A Color Removed* on the grounds that it "piled trauma on top of trauma" and made hasty associations between Rice's killing and multiple other forms of violence wreaked by global neoliberalism: gun violence writ large, the refugee crisis, Palestinian occupation, and so on (not unlike the state's arbitrary and hasty application of Safety Orange to elicit constant caution) ("Beyond Gestures").

30. Rakowitz explains that he sought and received consent from Samaria Rice to proceed with the project and has worked to maintain collaborative ties with Rice and the Tamir Rice Foundation. The orange objects donated for *A Color Removed* were given to Ms. Rice for use by the foundation and eventual exhibition in the Tamir Rice Afrocentric Cultural Center. The drop boxes used for donations have since been repurposed to collect art supplies for the Cuyahoga County Jail Coalition Arts and Culture Team to support teaching efforts at youth detention centers (Rakowitz, email to author, June 24, 2021).

with larger cultural debates over the right of non-Black artists to extract and display Black and Brown trauma subsumed under the sign of orange—a dynamic that threatens to abstract racial and ethnic violence from its lived experience, as some accused the artwork of abstracting the Blackness that underpins it and replacing it with orange.

By attempting to forge an intersectional politics, to create a kind of shared, cross-racial solidarity, *A Color Removed* offers a means of materializing—of making sensible and visible—calls for a radical collective vision for confronting a world beset by environmental and political crises.[31] However, attempts to forge a common language against structural forms of oppression are, for some, not only impossible but unethical. Perhaps the most resolute proponent of this argument is Afropessimist Frank B. Wilderson III, who has argued that Palestinian and Black communities (two communities whose suffering *A Color Removed* explicitly draws into comparison) do not "share a universal, postcolonial grammar of suffering" even if they share the position of being targeted for state oppression.[32] From such a perspective, artworks like *A Color Removed* can only ever fall into a form of solidarity politics that "analogize[s] black suffering with the suffering of other oppressed beings."[33]

This conviction—and the broader questions of who has the right to speak and to set the terms of representations about Black suffering—has been at the center of fierce debates by museums, curators, and artists following a series of explosive events in the

31. "Collective affect," T. J. Demos argues, in one such call, is "precisely what is needed in expressing the intangible sense of justice's necessary embeddedness and ultimate defining role in collective struggles like the Black radical tradition, decolonial praxis, and climate justice activism." Demos, *Beyond the World's End*, 11, 17.

32. Wilderson, *Afropessimism*, 16. "Why is anti-Black violence not a form of racist hatred but the *genome* of Human renewal; a therapeutic balm that the Human race needs to know and heal itself?" Wilderson writes (17, emphasis in original).

33. Wilderson, 14.

art world related to white and non-Black artists' representations of Black death.[34] In her book chronicling these events, critic Aruna D'Souza writes: "The question of when, and on what terms, a person is justified in taking up the cultural forms and historical legacies of groups (races, ethnicities, genders, etc.) to which they themselves are not part is always fraught, but especially so in the art world where cultural 'borrowings' are the cornerstone of the European avant-garde tradition we've been taught to admire."[35] Other artists, such as performance artist and theorist Coco Fusco, countered the polemical stance forwarded by Wilderson and others, asserting that "the argument that any attempt by a white cultural producer to engage with racism via the expression of black pain is inherently unacceptable forecloses the effort to achieve interracial cooperation, mutual understanding, or universal anti-racist consciousness."[36] My intention is not to adjudicate the ethics of using orange to bridge the representational chasms created by structural racism; it is merely to tease out why some artists have chosen to use the color, while others have not. By displacing the color onto objects and environments (rather than bodies), artists like Object Orange and Michael Rakowitz have employed Safety Orange's tendency toward abstraction precisely to avoid spectacularizing black suffering. And yet by virtue of its abstracting nature, orange cannot but inscribe black suffering in an attention economy that exceeds the boundaries of its lived experience, and thus threatens to perpetuate the very trauma it seeks to redress.

For these artists, the use of orange presents a double bind: it encodes both the moral imperative for non-Black artists to respond to Black suffering and the risk of inadvertently reproducing that suffering. Even as they struggle with this double bind, these works

34. Among these explosive events was the decision by the Whitney Biennial to exhibit *Open Casket,* white artist Dana Schutz's painting of Emmett Till.

35. D'Souza, *Whitewalling,* 37.

36. D'Souza., 40.

effectively advance Safety Orange as a conceptual tool for making visible the plight of certain subjects, communities, and environments. They suggest creative ways in which the color orange can be used to deflect state reprisal: to protect against arrest, to preserve against demolition, and to shield against other forms of legal retaliation. And yet at the same time, projects like *Detroit, Demolition, Disneyland,* and *A Color Removed* reveal the limits of an orange solidarity. These are not just the limits of a "politics of visibility," which assumes that raising awareness is the same as enacting social change—a promise that Safety Orange makes but never entirely fulfills. But more significantly, these projects show that when orange is used to resist oppression or neglect, it almost always abstracts (in a sense, removes) those being oppressed or neglected—and it is unclear to what extent it improves the lives of those it seeks to champion.

Ultimately, like Safety Orange, these artworks work by highlighting something different than they originally set out to highlight. By leveraging the slipperiness and mobility of Safety Orange as a sign, they further underscore the privilege that underlies orange's significatory power: they show *who* can make orange mean *what*. By using the color to remediate the state's failure to protect, these works cannot but participate in an attention economy that maintains whiteness' implicit authority to set the terms of signification. This is not a condemnation of these artworks but an invitation to think alongside them about the conditions that afford certain actors the power to make meaning and not others. Indeed, these same conditions bind this book, since they are inherent to the very medium used to make a problem visible: Safety Orange.

Conclusion: Seeing Red

WHAT SAFETY ORANGE TRULY WARNS OF is our entrenchment in preserving the status quo even in the face of system failure—climate change, neoliberal attrition, systemic racism. Orange both warns of and habituates citizens to a culture of deep insecurity—a new abnormal. By suggesting that everything is under control, Safety Orange partakes of the liberal logic of preservation, now reinforced under neoliberalism, by shifting onto individuals the duty to protect themselves from potential danger. But most disturbingly, orange combines its insistent warning with a curious call *not to act*. Orange is the imperative to skirt, to circumvent, to keep moving. *(There's nothing to see here.)* Its persistent presence in our visual and mediatic landscape trains us not to repair or replace the broken structure but simply to work around it. Safety Orange indefinitely defers the breaking point (the red of catastrophe) but also the tipping point (the red of revolution).

What can be done when the tools for communicating extreme crisis are emptied of meaning, made ineffective? As our closer examination of Safety Orange has revealed, the urgent-yet-permanent call to action eventually recedes into the background. It overloads our senses and dulls our collective sense of panic over system failure, diminishing our feeling that something has to change. If red is the color of total disruption—of either catastrophe or revolution—Safety Orange does not anticipate red but rather perpetually defers

it. Its liminal and incremental nature forecloses the possibility of operating outside the terms of *what is*. And yet, in the very ubiquity of orange, we can glimpse a possibility. If we can restore the color's original sense of warning, we might remediate the unjust distribution of care that underwrites contemporary U.S. neoliberal and racial economies. Safety Orange might show us how safety and protection are carved up, who they are given to, and why.

Acknowledgments

I am grateful for a faculty fellowship in the Institute for the Humanities Faculty Fellowship at the University of Michigan, which afforded me the time and resources to complete this book. The project benefited significantly from the superb research assistance of Yeshua Tolle, Dylan Volk, and Elizabeth McNeill. I thank Marq Smith and Manca Bajec and my anonymous reviewers for their generous and detailed feedback on an earlier article version that appeared in *Journal of Visual Culture*. These ideas gained coherence in dialogue with audiences at the Association for the Study of the Arts of the Present (ASAP) conference, the UM Department of English (special thanks to "Critical Conversations" organizers Katherine Hummel and Hayley O'Malley), and a UM Digital Studies Institute research workshop. I am deeply appreciative of those friends and colleagues who engaged with and offered encouragement for these ideas along the way: Johanna Gosse, Kris Cohen, Erica Levin, Sarah Ensor, Henry Cowles, Ingrid Diran, Jim Hodge, Patrick Jagoda, Peggy McCracken, Alex Pittman, Annie McClanahan, Danny Marcus, Sam McCracken, Cengiz Salman, Manan Desai, Justin Joque, Charlotte Karem Albrecht, Megan Ankerson, Abhishek Narula, Jasmine An, Silvia Lindtner, Sarah Murray, Osman Khan, and Kelly Wheeler. I am especially indebted to Lindsay Thomas for her outstanding engagement with the manuscript at multiple stages. Special thanks to artists Hank Willis

Thomas, Cameron Rowland, Amanda Williams, and Object Orange for granting me permission to reproduce their work in the Manifold version and to these artists' representatives: Rebecca Chang of Jack Shainman Gallery, Maxwell Graham of Essex Street Gallery, Bianca Marks of Marks On Canvas agency, and Paul Kotula of Paul Kotula Projects, respectively. I thank Michael Rakowitz and M. Carmen Lane (on behalf of *A Color Removed*) and Greg (last name redacted) (on behalf of Object Orange) for generously agreeing to be interviewed for this book. These pages are vastly better for the considerable talents of editors Heath Sledge and Kim Greenwell. I am grateful for the University of Minnesota Press's support of this project and am particularly indebted to Leah Pennywark for guiding this book to press and to Anne Carter for all of her help along the way. Additional gratitude to the Minnesota team is in order: my thanks to Scott Mueller, who copyedited this book, to Terence Smyre, who typeset and saw the book to print and online, and to Mike Stoffel, who saw it through production. Most of all, I thank Antoine Traisnel, for his significant contributions to and tireless support of this book. Any royalties from its sale will be donated to support organizations advocating for community-based solutions to state violence.

Bibliography

Agrell, Siri. "Detroit a Hotbed of Cool Art? Ah, Yes." *Globe and Mail,* February 27, 2010.

Ahmed, Sara. *What's the Use? On the Uses of Use.* Durham, N.C.: Duke University Press, 2019.

Arias, Elizabeth, Betzaida Tejada-Vera, and Farida Ahmad. "Provisional Life Expectancy Estimates for January through June 2020." *NVSS: Vital Statistics Rapid Release,* February 2021. https://www.cdc.gov/nchs/data/vsrr/VSRR10-508.pdf.

Ash, Juliet. *Dress behind Bars: Prison Clothing as Criminality.* London: I. B. Tauris, 2009.

Asonye, Chime. "There's Nothing New About the 'New Normal.' Here's Why." *World Economic Forum.* June 5, 2020. https://www.weforum.org/agenda/2020/06/theres-nothing-new-about-this-new-normal-heres-why/.

Associated Press. "Ex-Officer Told George Floyd Investigators That He Was Just a 'Human Traffic Cone' at Scene." *Cities Pioneer Press,* August 16, 2020. https://www.twincities.com/2020/08/16/ex-officer-told-george-floyd-investigators-that-he-was-just-a-human-traffic-cone-at-scene/.

Bass, Chloë. "An Artist Embarks on an Impossible Project for Tamir Rice." *Hyperallergic,* April 20, 2015. https://hyperallergic.com/200554/an-artist-embarks-on-an-impossible-project-for-tamir-rice/.

BBC News. "Why Do People Put Traffic Cones on Statues?" November 13, 2013. https://www.bbc.com/news/blogs-magazine-monitor-24925296.

Beam, Christopher. "Orange Alert: When Did Prisoners Start Dressing in Orange?" *Slate,* December 3, 2010. https://slate.com/news-and-politics/2010/12/when-did-prisoners-start-dressing-in-orange.html.

Beck, Ulrich. *The Risk Society: Towards a New Modernity.* London: Sage, 1992.

Beckett, Andy. "The Age of Perpetual Crisis: How the 2010s Disrupted Everything but Resolved Nothing," *Guardian,* December 17, 2019. https://www.theguardian.com/society/2019/dec/17/decade-of-perpetual-crisis-2010s-disrupted-everything-but-resolved-nothing.

Bello, Marisol. "Urban Art with a Cause: Look at the Blight, Color Shouts; Stealthy Painters Make Abandoned Houses Stand Out." *Detroit Free Press,* March 6, 2006.

Ben-Bassat, Tamar, and David Shinar. "Ergonomic Guidelines for Traffic Sign Design Increase Sign Comprehension." *Human Factors* 48, no. 1 (2006): 182–95.

Bendik-Keymer, Jeremy. "Beyond Gestures in Socially Engaged Art." *Public Seminar,* September 6, 2018. https://publicseminar.org/2018/09/beyond-gestures-in-socially-engaged-art/.

Berlant, Lauren. *Cruel Optimism*. Durham, N.C.: Duke University Press, 2011.

Boddy, Trevor. "Architecture Emblematic: Hardened Sites and Softened Symbols." In *Indefensible Space: The Architecture of the National Insecurity State,* edited by Michael Sorkin, 277–304. New York: Routledge, 2008.

Borland, David, and Russell M. Taylor. "Rainbow Color Map (Still) Considered Harmful." *IEEE Computer Society 27, no. 2* (March/April 2007): 14–17 https://ieeexplore.ieee.org/document/4118486.

Bradshaw, Corey J. A., Paul R. Ehrlich, Andrew Beattie, Gerardo Ceballos, Eileen Crist, Joan Diamond, Rodolfo Dirzo, et al. "Underestimating the Challenges of Avoiding a Ghastly Future." *Frontiers in Conservation Science* (January 13, 2021). https://doi.org/10.3389/fcosc.2020.615419.

Brannigan, Maura. "The Spring 2018 Runways Have Spoken: Safety Orange Is the New Millenial Pink." *Fashionista,* September 12, 2017. https://fashionista.com/2017/09/new-york-fashion-week-spring-2018-safety-orange-trend.

Brill, Steven. "15 Years After 9/11, Is America Any Safer?" *Atlantic,* September 2016. https://www.theatlantic.com/magazine/archive/2016/09/are-we-any-safer/492761/.

Brown University Climate and Development Lab (CDL) (Cole Triedman, Andrew Javens, Jessie Sugarman, and David Wingate). *Brown Climate and Development Lab Fall 2019 Utilities Report American Utilities and the Climate Change Countermovement: An Industry in Flux*.http://www.climatedevlab.brown.edu/uploads/2/8/4/0/28401609/cdl_utilities_report_fall_2019_.pdf.

Brown, Wendy. *Undoing the Demos: Neoliberalism's Stealth Revolution.* Brooklyn: Zone Books, 2015.

Browne, Simone. *Dark Matters: On the Surveillance of Blackness*. Durham, N.C.: Duke University Press, 2015.

Chun, Wendy Hui Kyong. *Updating to Remain the Same: Habitual New Media.* Cambridge, Mass.: MIT Press, 2016.

Climate Outreach. *Managing the Psychological Distance of Climate Change.* n.d. https://talk.eco/wp-content/uploads/Managing-the-Psychological-Distance-of-Climate-Change-Climate-Outreach-Guide.pdf.

Corsillo, Liza. "5 Ways to Wear Safety Orange Like a Street Style Star." *GQ,* February 3, 2017. https://www.gq.com/gallery/how-to-wear-safety-orange-like-a-street-style-star.

Cox, Josie. "COVID-19 and the Corporate Cliché." *Forbes,* April 22, 2020. https://www.forbes.com/sites/josiecox/2020/04/22/covid-19-corporate-cliche-why-we-need-to-stop-talking-about-the-new-normal/?sh=57483b4c159e.

Crary, Jonathan. *24/7: Late Capitalism and the Ends of Sleep.* London: Verso, 2013.

Dahl, Richard. "Green Washing: Do You Know What You're Buying?" *Environmental Health Perspectives* 118, no. 6 (2010): A246–52.

Davenport, Coral. "What Will Trump's Most Profound Legacy Be? Possibly Climate Damage." *New York Times,* November 9, 2020. https://www.nytimes.com/2020/11/09/climate/trump-legacy-climate-change.html?action=click&module=Top%20Stories&pgtype=Homepage.

Davies, Thom. "Slow Violence and Toxic Geographies: 'Out of Sight' to Whom?" Special issue, *EPC: Politics and Space* (April 10, 2019): 1–19. https://doi.org/10.1177/2399654419841063.

Davis, Angela. *Are Prisons Obsolete?* New York: Seven Stories Press, 2003.

Dawson, Michael C., and Megan Ming Francis. "Black Politics and the Neoliberal Racial Order." *Public Culture* 28, no. 1 (January 2016): 23–62.

Deleuze, Gilles. "Postscript on the Societies of Control." *OCTOBER* 59 (Winter 1992): 3–7.

Demos, T. J. *Beyond the World's End: Arts of Living at the Crossing.* Durham, N.C.: Duke University Press, 2020.

Detroit Free Press (editorial). "Bright Light on Blight: Painters Want to Catch Your Eye, and Your Concern, About Decay." March 10, 2006.

Dionne-Krosnick, Arièle. "What Color Is Racism?" Post: Notes on Art in a Global Context. Museum of Modern Art (MoMA), December 4, 2019. https://post.moma.org/what-color-is-racism/.

Diss, Kathryn. "Hong Kong Protesters Get Creative with Traffic Cones and Lasers as Demonstrations Escalate," *ABC News (Austrian Broadcasting Corporation),* August 6 2019. https://www.abc.net.au/news/2019-08-06/hong-kong-protesters-use-traffic-cones-against-tear-gas/11387296.

Doane, Mary Ann. "Information, Crisis, Catastrophe." In *New Media, Old Media: A History and Theory Reader,* edited by Wendy Hui Kyong Chun and Thomas Keenan, 251–64. New York: Routledge, 2006.

Drew, Kimberly, and Jenna Wortham. *"Color(ed) Theory*: Amanda Williams." In *Black Futures,* 132–35. New York: One World, 2020.

D'Souza, Aruna. *Whitewalling: Art, Race, & Protest in 3 Acts.* New York: Badlands Unlimited, 2018.

Eardley, Nick. "Coronavirus: Minister Defends 'Stay Alert' Advice Amid Backlash," *BBC News,* May 10, 2020. https://www.bbc.com/news/uk-52605819.

Ehrenreich, Ben. "We're Hurtling toward Global Suicide." *New Republic,* March 18, 2021. https://newrepublic.com/article/161575/climate-change-effects-hurtling-toward-global-suicide.

English, Darby. *To Describe a Life: Notes from the Intersection of Art and Race Terror.* New Haven, Conn.: Yale University Press, 2019.

Fleetwood, Nicole. *Marking Time: Art in the Age of Mass Incarceration.* Cambridge, Mass.: Harvard University Press, 2020.

Foster, Hal. "Père Trump." *OCTOBER* 159 (Winter 2017): 3–6.

Freinkel, Susan. *Plastic: A Toxic Love Story.* New York: Houghton Mifflin Harcourt, 2011.

Fuchs, Christian. *Digital Demagogue: Authoritarian Capitalism in the Age of Trump and Twitter.* London: Pluto Press, 2018.

Fuller, Thomas. "Coronavirus Limits California's Efforts to Fight Fires with Prison Labor." *New York Times,* August 22, 2020. https://www.nytimes.com/2020/08/22/us/california-wildfires-prisoners.html.

Furst, Jenner, and Julia Willoghby, dirs. *Fyre Fraud.* Hulu, 2019.

Galloway, Alexander. *Protocol: How Control Exists after Decentralization.* Cambridge, Mass.: MIT Press, 2004.

Ghosh, Amitav. *The Great Derangement: Climate Change and the Unthinkable.* Chicago: University of Chicago Press, 2017.

Ghosh, Bishnupriya, and Bhaskar Sarkar. "Media and Risk: An Introduction." In *The Routledge Companion to Media and Risk,* edited by Bishnupriya Ghosh and Bhaskar Sarkar, 1–24. New York: Routledge, 2020.

Gilmore, Ruth Wilson. *Golden Gulag: Prisons, Surplus, Crisis, and Opposition in Globalizing California.* Berkeley: University of California Press, 2007.

Gitelman, Lisa. *Always Already New: Media, History and the Data of Culture.* Cambridge, Mass.: MIT Press, 2014.

Green, Marc. "Color Discrimination." n.d. Visual Expert. https://www.visualexpert.com/FAQ/Part2/cfaqPart2.html.

Greenpeace. "PVC: The Poison Plastic." August 18, 2003. https://www.greenpeace.org/usa/wp-content/uploads/legacy/Global/usa/report/2009/4/pvc-the-poison-plastic.html.

Griffin, Tim. "Colors/Safety Orange." *Cabinet,* Summer 2002. http://www.cabinetmagazine.org/issues/7/colors7.php.

Hammons, David, Robert Storr, Alanna Heiss, Kellie Jones, Robert

Mnuchin, Sukanya Rajaratnam, and Mnuchin Gallery. *David Hammons: Five Decades.* New York: Mnuchin Gallery, 2016.

Hargraves, Hunter. "Tan TV: Reality Television's Postracial Delusion." In *A Companion to Reality Television: Theory and Evidence,* edited by Laurie Ouellette, 283–305. John Wiley & Sons, 2013.

Henderson, Dave. "Blaze Orange the Biggest Factor in Hunter Safety." *Press & Sun-Bulletin,* December 30, 2015. https://www.pressconnects.com/story/sports/columnists/2015/12/30/blaze-orange-biggest-factor-hunter-safety/78082326/.

Herrnstein Smith, Barbara. *Practicing Relativism in the Anthropocene: On Science, Belief, and the Humanities.* London: Open Humanities Press, 2018.

Hickman, Arvind. "PR Pros Lambast New Government 'Stay Alert' Slogan as 'Unclear' and 'Unhelpful.'" *PR Week,* May 12, 2020. https://www.prweek.com/article/1682781/pr-pros-lambast-new-government-stay-alert-slogan-unclear-unhelpful.

Hinton, Elizabeth. *From the War on Poverty to the War on Crime: The Making of Mass Incarceration in America.* Cambridge, Mass.: Harvard University Press, 2016.

Kapadia, Ronak. *Insurgent Aesthetics: Security and the Queer Life of the Forever War.* Durham, N.C.: Duke University Press, 2019.

Kelleher, Katy. "Blaze Orange, the Color of Fear, Warnings, and the Artificial." *Paris Review,* October 31, 2018. https://www.theparisreview.org/blog/2018/10/31/blaze-orange-the-color-of-fear-warnings-and-the-artificial/.

Klein, Naomi. *This Changes Everything: Capitalism vs. the Climate.* New York: Simon & Schuster, 2015.

Kobylewski, Sarah. "CSPI Says Food Dyes Pose Rainbow of Risks: Cancer, Hyperactivity, Allergic Reactions." *Center for Science in the Public Interest,* June 29, 2010. https://cspinet.org/new/201006291.html.

Larsson, Andreas. "The Art of Abandonment." *Economist* 393, 8662 (December 19, 2009): 55–58.

Lefferts, Lisa Y. "Seeing Red: Time for Action on Food Dyes." *Center for Science in the Public Interest,* 2016. https://cspinet.org/sites/default/files/attachment/Seeing%20Red.pdf.

Lin, Sharon, and Jeffrey Heer. "The Right Colors Make Data Easier to Read." *Harvard Business Review,* April 23, 2014. https://hbr.org/2014/04/the-right-colors-make-data-easier-to-read.

Ma, Tracy, Natalie Shutler, and Jonah E. Bromwich. "Why Protest Tactics Spread Like Memes." *New York Times,* July 31, 2020. https://www.nytimes.com/2020/07/31/style/viral-protest-videos.html.

Malm, Andreas. *Fossil Capital: The Rise of Steam Power and the Roots of Global Warming.* New York: Verso, 2016.

"Marking of Toy, Look-Alike and Imitation Firearms." Title 15 *Code of Federal Regulations,* Pt. 1150.3. 2011 ed.

Marshall, George. *Don't Even Think About It: Why Our Brains Are Wired to Ignore Climate Change*. New York: Bloomsbury, 2015.

Masco, Joseph. *The Theater of Operations: National Security Affect from the Cold War to the War on Terror*. Durham, N.C.: Duke University Press, 2014.

Massumi, Brian. "The Autonomy of Affect." *Cultural Critique*, no. 31 (Autumn 1995): 83–109.

McGlotten, Shaka. "Black Data." In *No Tea, No Shade: New Writings in Black Queer Studies*, edited by E. Patrick Johnson, 263–86. Durham, N.C.: Duke University Press, 2016.

McKenna, Maryn. "To Navigate Risk in a Pandemic, You Need a Color-Coded Chart." *Wired*, July 21, 2020. https://www.wired.com/story/to-navigate-risk-in-a-pandemic-you-need-a-color-coded-chart/.

Menely, Tobias, and Margaret Ronda. "Red." In *Prismatic Ecology: Ecotheory beyond Green*, edited by Jeffrey Jerome Cohen, 22–41. Minneapolis: University of Minnesota Press, 2013.

Mirzoeff, Nick. "Watching Whiteness Shift to Blue Via Nationalist Aesthetics." *Hyperallergic*, November 30, 2020. https://hyperallergic.com/603860/watching-whiteness-shift-to-blue-via-nationalist-aesthetics/.

Moore, Jason W. "Introduction: Anthropocene or Capitalocene? Nature, History, and the Crisis of Capitalism," In *Anthropocene or Capitalocene? Nature, History, and the Crisis of Capitalism*, edited by Jason W. Moore, 1–13. Oakland, Calif.: PM Press, 2016.

Moynihan, Colin. "A New York Clock That Told Time Now Tells the Time Remaining." *New York Times*, September 20, 2020. https://www.nytimes.com/2020/09/20/arts/design/climate-clock-metronome-nyc.html.

Munger, Sean. "Avoiding Dispatches from Hell: Communicating Extreme Events in a Persuasive, Proactive Context." In *Addressing the Challenges in Communicating Climate Change across Various Audiences*, edited by Walter Leal Filho, Bettina Lackner, and Henry McGhie, 115–27. Cham: Springer, 2019.

Neely, Michelle C. *Against Sustainability: Reading Nineteenth-Century America in the Age of Climate Crisis*. New York: Fordham University Press, 2020.

Nelson, Megan Kate. "A Brief History of the Stoplight." *Smithsonian Magazine*, May 2018. https://www.smithsonianmag.com/innovation/brief-history-stoplight-180968734/.

Ngai, Sianne. *Theory of the Gimmick: Aesthetic Judgment and Capitalist Form*. Cambridge, Mass.: Belknap Press of Harvard University Press, 2020.

Nguyen, Mimi Thi. "The Hoodie as Sign, Screen, Expectation, and Force." *Signs* 40, no. 4 (Summer 2015): 791–816.

Nixon, Rob. *Slow Violence and the Environmentalism of the Poor.*
 Cambridge, Mass.: Harvard University Press, 2011.

NYCLU. "Stop-and-Frisk Data." n.d. https://www.nyclu.org/en/stop-and-
 frisk-data.

Object Orange. "Detroit. Demolition. Disneyland." *Detroiter,* November
 2005. http://www.thedetroiter.com/nov05/disneydemolition.php.

O'Neil, Cathy. *Weapons of Math Destruction: How Big Data Increases
 Inequality and Threatens Democracy.* New York: Crown Books, 2016.

Oxford English Dictionary. 3rd ed. S.v. "risk." Oxford: Oxford University
 Press, 2010.

Pearce, Julia. "Feeling Alert? Where the UK Government's New
 Coronavirus Campaign Went Wrong." *Conversation,* May 15,
 2020. https://theconversation.com/feeling-alert-where-the-uk-
 governments-new-coronavirus-campaign-went-wrong-138572.

Pettman, Dominic. *Infinite Distraction.* Malden, Mass.: Polity Press, 2016.

Puar, Jasbir K. *The Right to Maim: Debility, Capacity, Disability.* Durham,
 N.C.: Duke University Press, 2017.

Rahmani, Aviva, and Jillian Steinhauer. "Using Art to Stop a Pipeline."
 Hyperallergic, September 9, 2015. http://hyperallergic.com/235429/
 using-art-to-stop-a-pipeline/.

Remnick, David. "The Biden Era Begins: American Democracy Has
 Survived Donald J. Trump." *New Yorker,* November 7, 2020. https://
 www.newyorker.com/magazine/2020/11/16/the-biden-era-begins.

Rexroat, Kelsey. "The Day the San Francisco Sky Turned Orange." *New
 Yorker,* April 20, 2021. https://www.newyorker.com/culture/video-
 dept/the-day-the-san-francisco-sky-turned-orange.

Rogers, Katie. "In the Pale of Winter, Trump's Tan Remains a State
 Secret." *New York Times,* February 2, 2019. https://www.nytimes.
 com/2019/02/02/us/politics/trump-tan.html.

Rose, Nikolas. "The Death of the Social? Re-figuring the Territory of
 Government." *Economy and Society* 25, no. 3 (August 1996): 327–56.

Rost, Lisa Charlotte. "What to Consider When Choosing Colors for
 Data Visualization." *Chartable: A Blog by Datawrapper,* May 29, 2018.
 https://blog.datawrapper.de/colors/.

Sargent, Antwaun. "Amanda Williams' Color Theories." *Interview
 Magazine,* October 9, 2015. https://www.interviewmagazine.com/art/
 amanda-williams-color-theories.

Schimminger, Morgan C. "Sorry Pantone, Fashion Has an Orange
 Crush for 2019." The Fashion Spot, January 4, 2019. https://www.
 thefashionspot.com/style-trends/819349-wear-orange/.

Science and Security Board (SASB). "2019 Doomsday Clock Statement: A
 New Abnormal; It Is *Still* Two Minutes to Midnight." *Bulletin of the
 Atomic Scientists,* January 24, 2019. https://thebulletin.org/doomsday-
 clock/2019-doomsday-clock-statement/.

Shapiro, Jacob N., and Dara Kay Cohen. "Color Bind: Lessons from the Failed Homeland Security Advisory System." *International Security* 32, no. 2 (Fall 2007): 121–54.

Shore, Chris. "Audit Culture and the Politics of Responsibility: Beyond Neoliberal Responsibilization?" In *Competing Responsibilities: The Ethics and Politics of Contemporary Life,* edited by Susanna Trnka and Catherine Trundle, 96–117. Durham, N.C.: Duke University Press, 2017.

Snodgrass, Susan. "Painting as Urban Archaeology." *In/Site: Reflections on the Art of Place.* Blogpost, August 1, 2015. https://susansnodgrass.com/2015/08/01/painting-as-urban-archeology/.

Sorkin, Amy Davidson. "Trump Wanted a Big Sendoff—and Didn't Get It." *New Yorker,* January 21, 2021. https://www.newyorker.com/news/daily-comment/trump-wanted-a-big-sendoff-and-didnt-get-it.

Spade, Dean. *Mutual Aid: Building Solidarity during this Crisis (and the Next).* London: Verso Books, 2020.

Stridger, Ruth W. "How Readable Are Your Street Signs?" *Better Roads* 73, no. 8 (2003): 3638.

Svachula, Amanda. "Artist Uses Pieces of Demolished South Side Houses in MCA Exhibit." *Chicago Sun Times,* August 20, 2017. https://chicago.suntimes.com/2017/8/20/18448855/artist-uses-pieces-of-demolished-south-side-houses-in-mca-exhibit.

Thomas, Lindsay. "Forms of Duration: Preparedness, the *Mars* Trilogy, and the Management of Climate Change." *American Literature* 88, no. 1 (March 2016): 159–84.

Thomas, Lindsay. *Training for Catastrophe: Fictions of National Security After 9/11.* Minneapolis: University of Minnesota Press, 2021.

Trnka, Susanna, and Catherine Trundle. "Competing Responsibilities: Reckoning Personal Responsibility, Care for the Other, and the Social Contract in Contemporary Life." In *Competing Responsibilities: The Politics and Ethics of Contemporary Life,* edited by Susanna Trnka and Catherine Trundle, 1–26. Durham, N.C.: Duke University Press, 2017.

U.S. Department of Transportation Federal Highway Administration. "The History of Traffic Cones." *Manual on Uniform Traffic Control Devices for Streets and Highways.* https://mutcd.fhwa.dot.gov.

U.S. Department of Transportation Federal Highway Administration. "Your MUTCD: Guiding You for over 80 years." *Manual on Uniform Traffic Control Devices for Streets and Highways.* https://mutcd.fhwa.dot.gov.

U.S. Food and Drug Administration. "Color Additives Questions and Answers for Consumers." January 4, 2018. https://www.fda.gov/food/food-additives-petitions/color-additives-questions-and-answers-consumers#:~:text=The%20FDA%20requires%20food%20manufacturers,abbreviated%20name%2C%20Blue%201.

Van Veeren, Elspeth. "Orange Prison Jumpsuit." In *Making Things International 2: Catalysts and Reactions,* edited by Mark B. Salter, 122–36. Minneapolis: University of Minnesota Press, 2016.

Walker Rettberg, Jill. "Ways of Knowing with Data Visualizations." In *Data Visualization in Society,* edited by Martin Engebretsen and Helen Kennedy, 35–48. Amsterdam: Amsterdam University Press, 2020.

Wallace-Wells, David. *The Uninhabitable Earth: Life After Warming.* New York: Tim Duggan Books, 2020.

Wang, Jackie. *Carceral Capitalism.* South Pasadena, Calif.: Semiotext(e), 2018.

Whyte, Liz Essley. "42 States are Now in the Red Zone for Coronavirus Cases, White House Says." The Center for Public Integrity, November 10, 2020. https://publicintegrity.org/health/coronavirus-and-inequality/42-states-are-now-in-the-red-zone-for-coronavirus-cases-white-house-says/.

Wickens, Christopher D., Sallie E. Gordon, and Yili Liu. *An Introduction to Human Factors Engineering.* 2nd ed. London: Pearson, 2003.

Wilderson III, Frank B. *Afropessimism.* New York: Liveright, 2020.

Wilke, Claus O. "Common Pitfalls of Color Use." In *Fundamentals of Data Visualization: A Primer on Making Informative and Compelling Figures.* eBook. Self-published, n.d. https://clauswilke.com/dataviz/color-pitfalls.html.

Williams, Amanda. "Conclusion: Radical Acts." 2014–16. Museum of Modern Art, New York City.

Zacks, Stephen. "Orange Alert," *Metropolis,* June 1, 2006. https://www.metropolismag.com/uncategorized/orange-alert/.

(Continued from page iii)

Forerunners: Ideas First

Anna Watkins Fisher is associate professor of American culture at the University of Michigan, Ann Arbor. She is the author of *The Play in the System: The Art of Parasitical Resistance* and coeditor of the second edition of *New Media, Old Media: A History and Theory Reader.*